THE BOOK OF NIGHTS

Dedalus published Sylvie Germain's The Book of Nights to great acclaim last autumn. It was awarded The Scott-Moncrieff Prize for the best translation of a Twentieth Century French Novel into English during 1992.

These are a few of the comments:

'*The Book of Nights* is a masterpiece. Germain is endowed with extraordinary narrative and descriptive abilities ... She excels in portraits of emotional intensity and the gritty realism of raw emotions gives the novel its unique power. *The Book of Nights* is a literary feast.'
Ziauddin Sardar in The Independent

'This astonishing first novel has won no less than six literary prizes since its publication in 1985. The novel tells the story of the Peniel family in the desolate wetlands of Flanders, across which the German invaders pour three times – 1870, 1914 and 1940 – in less than a century. It is hard to avoid thinking of *A Hundred Years of Solitude* but the comparison does no disservice to Germain's novel, so powerful is it. . . . A brilliant book, excellently translated'.
Mike Petty in The Literary Review

'*The Book of Nights* is a moving and powerful book.'
Claire Messud in The European

'This is a lyrical attempt to blend magic realism with *la France profonde*, the desolate peasant regions that remain mired in myth and folklore. Nothing is too grotesque for Germain's eldritch imagination: batrachian women, loving werewolves, necklaces of tears and corpses that metamorphose into dolls all combine to produce a visionary fusion of the pagan and the mystical.'
Elizabeth Young in The New Statesman

'an unusual and a passionate book'
Barbara Wright in The Times Literary Supplement

'It is remarkable for its passionate, fantastic, bloody and over-populated pages. I look forward to the sequel, *Nuit d'ambre* which Dedalus has promised us for 1994.'
Peter Lawson in City Limits

'Ruth's fate and that of her adopted family are described with dazzling conviction and the terror of the Nazi occupation evoked with stunning power.
James Friel in Time Out

'a triumph of bizarre and poetical imagination'.
Madeleine Kingsley in She

Translated from the French
by Judith Landry

The Weeping Woman on the Streets of Prague

Sylvie Germain

with an interview by Elizabeth Young and
an introduction by Dr Emma Wilson

Dedalus

Dedalus would like to thank The French Ministry of Culture and Eastern Arts for their assistance in producing this translation.

Published in the UK by Dedalus Limited, Langford Lodge, St Judith's Lane, Sawtry, Cambs, PE17 5XE

ISBN 1 873982 70 4
Distributed in Australia & New Zealand by Peribo Pty Ltd, 26, Tepko Road, Terrey Hills, N.S.W. 2084

First published in France as La pleurante des rues de Prague
La pleurante des rues de Prague copyright © 1992 Editions Gallimard
First English edition 1993
Translation copyright Dedalus 1993

Typeset by Datix International Limited, Bungay, Suffolk
Printed in England by Loader Jackson, Arlesey, Beds

This book is sold subject to the condition that it shall not, by way of trade or otherwise, be lent, resold, hired out, or otherwise circulated without the publisher's prior consent in any form of binding or cover other than that in which it is published and without a similar condition including this condition being imposed on the subsequent purchaser.

A C.I.P. listing for this title is available on request

THE AUTHOR

Sylvie Germain was born in Chateauroux in Central France, in 1954. She read philosophy at the Sorbonne, being awarded a doctorate. Since 1987 she has taught philosophy at the French School in Prague. She is the author of five novels and one collection of short stories. Her novels have been translated into fifteen languages.

Sylvie Germain's first novel *Le Livre des nuits* (*The Books of Nights*) was published to great acclaim in France in 1985. It has won six Literary Prizes in France and The Scott-Moncrieff Translation Prize in England. The novel ends with the birth of Night of Amber and his story is continued in *Nuit d'ambre* (1987), which Dedalus will be publishing in 1994. Her third novel *Jours de colere* (*Days of Anger*, Dedalus 1993) won the Prix Femina. It was followed in 1991 by *L'enfant Meduse*, (Dedalus edition in preparation for 1994), before *La pleurante des rues de Prague* in 1992.

THE TRANSLATOR

Judith Landry was educated at Somerville College, Oxford where she obtained a first class honours degree in French and Italian. She combines a career as a translator of fiction, art and architecture with part-time teaching at the Courtauld Institute, London.

For Dedalus she has translated Giovanni Verga's *The House by the Medlar Tree*, Jacques Cazotte's *The Devil in Love* and the novella of Charles Nodier, *Smarra* and *Trilby*.

To my brother,
to my sisters.

Sylvie Germain – Interview

If ever anyone looked like a writer of magical, mystical books it is Sylvie Germain. Dressed in grey with a hint of antique embroidery or lace to the costume, she is as insubstantial as smoke. She has large, tip-tilted cat's eyes, heavily ringed with kohl and a soft cloud of tobacco-coloured hair. Her jewellery is ornate, nacreous; crescent moons, seed-pearls and beaten silver. She is oblique, evanescent. It seems brutal to intrude on someone so evidently fragile, someone so elusive and dream-like, someone barely visible behind clouds of smoke in a darkened room. And yet, despite this resemblance to a priestess at arcane rites, she is obviously an extremely hard-working and professional author. 'The Book of Nights', the first of her five novels, was published by Gallimard in France in 1985 and won six literary prizes. It was equally well-received when published in Britain by Dedalus in 1992. At the time I spoke to Sylvie Germain 'The Book of Nights' was the only one of her novels to have been translated into English and she explained its curious derivation. She had intended to write what was to become her second novel 'The Book of Amber', but in tracing the ancestry of Charles-Victor Peniel or 'Night-of-Amber', the hero of 'The Book of Amber', she found she was writing a prologue so lengthy and intense that it had become a novel in its own right. This implies an intense creative fecundity which is amply borne out by the inventive and grotesque thaumaturgy of her first novel. There were many questions I wished to ask her about the book and about her writing in general and the interview was conducted in fractured French with the helpful intervention of her translator Christine Donougher. Germain was not evasive but elliptical. Her thoughts seemed to inhabit a

private, deeply felt shadow-realm and there was something ghostly about her responses, as if forgotten wars and literary characters meant far more to her than an intrusive present.

Germain had originally studied philosophy which she described as 'a continuous wonder' to her. However, feeling that she lived more in 'dream and imagination' and wasn't sufficiently 'analytical' for an entire career in philosophy, she turned to literature, finding writers such as Dostoevsky and Kafka to be as enthralling as philosophical study. She had been particularly drawn to phenomenology and moral philosophy, to Plotinus, Descartes, Husserl and Heidegger, which may go some way to explaining her emphasis, in literature, on suffering, pain and transcendence.

'The Book of Nights' can be described as a lyrical attempt to blend magic realism with *la France profonde*, the desolate peasant regions that have remained mired in myth and folklore and have changed relatively little down the decades. Germain, who grew up in rural France, agrees 'that the power of place had a huge effect on me but it was an unconscious one.' She acknowledges that her writing is 'related to the earth' and that 'the soil, the peasants, the trees', all the fables and sagas of a land eroded by history have been of great importance in her writing.

When asked if there were any parallels between the way South American writers have drawn on the history of sorcery and magic in their country and what seem to be her own attempt to provide a magical realism for the very different myths of France, Germain emphasises the individual nature of her work. She says that she is 'trying only to express an obsessive image and to explain it to myself. I have no pretensions to creating a mythos. Each book begins with an image or a dream and I try to express that and give it coherence.' In the case of 'The Book of Nights' and 'The Book of Amber' – which really need to be read in tandem – the image was that of Jacob wrestling with the angel – 'one

of the strongest representations of man's destiny on earth.' It is an image that does not appear until the end of the second book, by which time the author has taken us through the Franco-Prussian war of the 1870s, the two world wars, and the Algerian war – which illustrates something of Germain's capacity for impassioned obsession.

Germain insists that her work arises out of 'a plethora of images and unconscious revelations' and that she does not make any distinction between the imaginary and the real. She depends on dreams for much of her source material and comments 'I feel that the dream life, the life of the imagination, is very structured.' Does this mean she agrees with Lacan that 'The unconscious is structured like a language'? She thinks this is probable but adds that Lacan 'is too difficult for me.'

'The Book of Nights' covered a century in the lives of the Peniels, a peasant family, living in Blackland, a desolate Flanders village. The family suffer terribly through the wars of 1870, 1914 and 1939 when German invaders pour through the wetlands of Flanders. The patriarch of the book is Victor-Flandrin, also known as Night-of-Gold-Wolf-Face, marked as he is by a fleck of gold in his eye and an ability to charm the semi-mythical wolves that still roamed the land. Victor-Flandrin has four wives and begets numerous children, fifteen in all, either twins or triplets and all characterized by the gold speck in their left eye. One birth is almost wholly mystical – he rapes a woman who seems intended as some sort of archetypal spirit of the woods who gives birth to the triplets, named after the archangels, Michael, Gabriel and Raphael. Victor-Flandrin's last wife, the Jewess Ruth, is taken to die in Sachsenhausen and he himself commits suicide in an agony of grief. The Peniel family are splintered upon the oppositions of love and death. Many of the magical events in the book are clustered around the moments of birth and death. Victor-Flandrin's

mother gives birth, after a twenty-one month pregnancy, to a 'little salt baby' and dies. The bodies of Victor-Flandrin's dead wives turn into dolls, wood and glass, or music. Victor-Flandrin himself wears a necklace of tears and is haunted by the smile of his grandmother.

Germain agrees birth and death are the times when the transcendent is most likely to break through but emphasises that the period in between, life itself, is also a dream. However she stresses that fundamentally it was the subject of war that engrossed her: 'I was interested to see how wars can come and destroy men's lives.' It is wars that compel the visions, the violence, the devastation and the bizarrerie of the book.

Victor-Flandrin/Night-of-Gold-Wolf-Face is an immensely powerful and resonant character. It is possible to discern within his being the lineaments of European myth – the vampire, the werewolf, Bluebeard. Germain talks about the ways in which we are influenced by the culture around us, 'family, collective, national.' 'As Jung says, we are marked by the great myths. When I was little I grew up in the area of the "loup-garou" (werewolf). Nearby was a great statue of a monstrous wolf from the last century – a half-mythic beast which was supposed to have eaten people. I think I was unconsciously marked by this myth.' Germain's writing demonstrates a great tenderness towards living things, even those as supposedly threatening as wolves, but she comments 'I was frightened of animals. I am still frightened of them. I thought it was my fault. I thought of St. Francis of Assissi. I felt it was my fault I was afraid because I did not love them.' Germain's answer is again revealing of the moral struggle that lies at the heart of her work, a struggle to understand, to survive and ultimately to forgive that which is most threatening and repulsive, whether wars, deaths or interminable *contes cruels*.

Germain's three great themes are language, religion and

war. Naming is very important in 'The Book of Nights.' Names are sometimes not spoken at all, or two names are collapsed into one. Many of the characters come with great difficulty to language. There are two mystical passages which seem to seek the sources of language and to test its limits in visionary and spiritual terms. The first begins 'God created the world and all things in the world but he did not give anything a name.' This takes us to a discourse on the mystical rose – a classic Catholic image – and ends in virtual glossolalia, 'Rose-red, rose-night. Night-blood and fire-wind-blood. Rose-red-raw.' The second passage again ponders the mystery of language and naming but this time damns those who distort the divinity of language and coat 'all things with a layer of black blood.' Here the rose stands for blood, 'blood-night and fog . . . ashes and dust.' Death. Although Germain concedes 'I have become ever more obsessive about the limits of language', she nevertheless distances herself entirely from any current theories of language in French thought. These issues within her work 'arise only in retrospect. As I write I never think about these things. In the Bible, naming is magic, divine. It is given to man to name the animals. There is an aspect of the divine in naming things.' She concludes sombrely 'You can betray or save someone with a single word.' Germain's work has a profoundly religious and mystical feel to it although she appears to reject conventional everyday Catholicism. She refers, for example, to "the black odour of sanctity.' Is it possible that she makes a distinction between a corrupt Catholic church and a more spiritual, a more real apprehension of God? Victor-Flandrin has a vision of the world, the earth as the source of all power and energy – 'Only the earth remained inalterably the same – an immemorially age-old body endowed with fantastic vigour . . . It was a faceless, nameless god, immanent in the earth, made of stones, roots and mud. An Earth-god that rose up in forests and moun-

tains and flowed in rivers . . .' Two of the triplets, Gabriel and Michael, could be called unnatural both in that they turn their backs on their family and join the Germans in WWII, and in that they have a homo-erotic relationship. Yet they are quintessentially of the forest and their rampant desire to kill could also be seen as wholly natural. Is Germain locating a pagan source of spirituality? Does she feel that Catholicism has become degraded and that we must apprehend God in other ways? Germain responds 'I am Catholic by family. Catholicism – the pictorial, the statuary – has been very decisive in forming my imagery. All these images are important. They can lead to faith but at the same time they can eclipse faith. The problem for Victor-Flandrin/Night-of-Gold is not really one of religion but is a problem that afflicts all humanity – a sadness too great to be borne.' Germain refers to a description by Elie Wiesel of people in a concentration camp looking at a child who has been left to die by hanging. 'They cry "Where is God?" This is a suffering too great for humanity. Francois Mauriac has commented that the dying child is Christ. This is less a problem of religion as an institution than a problem directly between God and the individual. The problem for the people in 'The Book of Nights' is the same as for those in the concentration camp. Why are all the people I loved killed? Why do all the people I love die? Is this ineffable mysticism or do I reject God? Victor-Flandrin is tried by too much suffering. Many people who suffer greatly, and particularly those who suffer the death of children become fervent churchgoers – or else they reject God completely.'

The name 'Peniel' is the name of the mountain on which Jacob wrestled with the angel. The natural world, she says is *'vraiment cruel'*. Gabriel and Michael, both as symbols and as characters, are 'extreme examples. They are just amoral. They have no moral sense. There are people like that.'

Germain goes on to describe Charles-Victor Peniel, Victor-Flandrin's grandchild, 'the last-born of the Peniel line. The postwar child. The child born after all the wars.' He is the anti-hero of 'Book-of-Amber.' He grows up very savage and as a young man is cynical and immoral. He has not participated in war but wishes to transgress; he likes to destroy and chooses to commit crime. He provokes the death of a good person and is unable to assume responsibility for the crime. He is tormented by remorse. (The Dostoevskyan echoes seem unmistakable.) Germain says 'He comes to realise the monstrosity of his act. It is the history of a man who comes to learn that you cannot kill like that. It is a journey towards salvation.'

It seems clear from all Germain has said that she is motivated by an immense, heart-breaking pity for human suffering particularly during the atrocities of war 'There could be nothing but yesterdays now' thinks Victor-Flandrin, after the Germans have slaughtered his village. Additionally her work is extremely personal, depending primarily on her own individual unconscious 'childhood memories, emotions, sensations, dreams' for its force and impetus rather than on literary or philosophical fashions. 'All my books are about the problem of evil' she concludes. Can her work be described, therefore, as a search for God? 'Yes' says Germain, very emphatically.

<div align="right">Elizabeth Young</div>

Sylvie Germain: An Introduction

The Weeping Woman is a fractured tale, poised between vision and elegy. It first appeared in France in 1992, included in Gallimard's prestigious collection, 'L'Un et l'autre', a series devoted to themes of the self and other, fantasy identities and fictive models. For Sylvie Germain, relations between self and other are constantly at issue in her fictions. Yet, as French critics have commented, her first novel, *The Book of Nights* is starkly and startlingly different from the usual autobiographical offerings of first time writers. Germain takes us instead into an ordered and private world of nightmare, obsessive symbols and forbidden passions. She merges the metaphorical and the real so completely that the reader is led into a postmodern hyperreality, a minutely charted oneiric landscape. Germain combines limpid and lyrical prose with an almost macabre imagination; she seizes fleeting, uncanny images which create a hallucinatory effect, leaving her fiction marked by an entirely singular intensity.

In *The Weeping Woman* Germain approaches the themes that have become familiar in her novels – loss, suffering, desire – but takes them for the first time in her fiction outside France. Like her Parisian tale *Opéra muet* (published in 1989), *The Weeping Woman* is a text of the city, whose tale is traced through the streets of Prague. Germain focuses on an elusive and diaphanous phantom, a weeping woman whose appearances modulate the course of the text. It is indeed her entrance into the text which marks the opening of the tale. Germain shows the phantom figure entering the text as if it were an empty house or abandoned garden: Germain's Prague is a city of absence and desolation, a metaphorical location echoing perhaps the metropoli-

tan spaces of Rimbaud's *Illuminations*. Poetic allusions serve to structure the text as a whole. Germain draws on a series of modern Czech poets (among them Vladímir Holan and Jaroslav Seifert) whose work holds affinities with the tale she tells of grief in a city. One might aptly quote a poem by Seifert, not mentioned by Germain, which opens with the lines: 'A sharply-drawn picture of suffering / is the town', and which holds the title 'Town in Tears'. Prague, in *The Weeping Woman*, stands as this town in tears; tears and mourning fill the lines Germain chooses from Czech poetry. She opens, indeed, with the following lines from Holan: 'we have long measured the years in tears'. Germain seeks this measurement in tears and encoding of grief.

The Weeping Woman is a tightly controlled text formed by the twelve appearances of the phantom figure. These take place each time in a different part of the city of Prague and Germain provides us with precise geographical locations. The first appearance takes place in the centre of the old town near the St Nicholas Church and the Tyn Church. Germain's phantom begins her itinerary in the heart of Prague, in the shadow of the city's most celebrated landmarks, before moving and circling outwards to the Olsany cemeteries, Mala Strana, the hillside of Vysehrad, the Palacky bridge and areas of the new town. The reader can follow the course of the book on a map of Prague; the phantom's itinerary forms the book in such a way that Germain's Prague becomes, like Paul Auster's New York, a textual city and sign system.

Germain is concerned not only with streets and landmarks, but with precise detailing of the atmosphere, the light, the transience of the city. She adds descriptions of the time of day, the season, the colours in the sky, yet these seemingly banal references add, in fact, a derealising effect. In a peculiarly arresting image Germain describes the city taking on 'a greenish tint, vaguely chilling, like an aquarium

lit with neon'. The light, like Germain's text, renders the city strange. In the narration of the phantom's second appearance, 'in the opalescent mist, all the passers-by looked like ghosts': Germain's unreal city appears entirely populated by phantoms. Her writing is exquisite, indeed, in its capturing of shifting states and the floating image. She makes of her text a study of visibility and of the relation between image and memory. The weeping woman is described as a product of the play of light, displaying 'an incorporeal and transient beauty born of the refraction of light rays in raindrops'. The drops of rain are mingled in the text with the tears the phantom weeps: she is seen also as an apparition called forth in the 'grief of all men and women'.

Sylvie Germain, like the novelist Marguerite Duras, creates texts which evoke suffering within history, within tales which are emphatically personal. In *The Weeping Woman* she creates a lament of the contemporary city which, while alluding to the events of twentieth-century history, seeks to reveal rather the history of the individual. She tries, variously, to give a body to history, writing: 'There is no such thing as time in the abstract: time is always the time of a body which feels and bears it, the time of the history of a living person'. The image mutates so that history itself becomes a body and Germain writes, echoing Shakespeare, in wonderfully baroque prose: 'The body of History is like that of a drowned man who has long lain on the sea bed, and whose ravaged flesh has become encrusted with all manner of shells, algae, corals and underwater flowers'.

The image of the body is central to Germain's work, and what is distinctive is the way she describes the mutilation of the flesh. Perpetuating her image of the body in history she writes: 'And the more the flesh is ravaged, the more the shells, the flowers of mother-of-pearl, the accretions of tears and blood, proliferate. The more the flesh is distorted,

mutilated, the more myriads of eyes and gaping mouths open in its wounds'. Germain would appear to imagine her own text rising out of suffering, and as an act of reparation. The weeping woman is seen to move between the bodies of the dead and of the living. She steps between two worlds, that of the visible and that of the invisible, that of the present and that of the past, as does Germain herself within the text.

The Weeping Woman also serves to place Germain, or her fictive persona, within her work for the first time. In this text of self and other, there is an unnamed I who perceives and recounts the appearances of the weeping ghost. Germain focuses in most detail on the perceiving subject in the narration of the eighth appearance. Up until this point in the book the action and narrative have been entirely exterior; here, however, Germain takes us within, noting that the phantom also appears in interiors, and in 'lieux clos'. She provides us with an illuminated image where the writer is figured reading in an oval of light, taking on the appearance of a woman in a Vermeer painting: 'Seated at a table in this furnished room, I was reading. A metal lamp, painted in a dubious eggshell white, cast an oval of light onto the book, and the objects around it striped the cloth with strokes of oblique shadow'.

This identification of the self within the text leads to Germain's most detailed meditations on desire. The weeping woman shadows the self in the text, and mediates between personal grief and public suffering. She forms a doubling other for the self Germain has created. Yet within this text Germain explores the very (im)possibilities of doubling relations. She writes: 'This is the lover, who becomes our body's twin: our second body. Who, although alien, because alien, becomes consubstantial with us, through the ways of desire which run oblique to those of consanguinity'. This image of the lover as double, as second body which is both

alien and desired, relates tellingly to the thematics of twinship which frequently recurs in Germain's fiction. Her work is at its most poignant and captivating when she dwells on the impossible divide between lover and object of desire. She reveals the cognitive nature of desire, and the quest for possession of the body of the other, writing: 'Because we have looked upon it, encircled it, caressed it, slept up against it, in its warmth and smell, because we have desired it with a desire ever-growing even at the height of its sating, we know that other as no other knows it'.

Making love with the body of the other becomes an act of reading the body. Germain describes the process of 'rereading, with our lips and fingers as much as with our eyes'. This desire to touch and taste the other, and its figuring in terms of reading relations, is in some senses reminiscent of Hélène Cixous's work on the body in the text. Germain does not, however, identify herself with *écriture féminine* or specifically, as a female writer. She would seem instead to seek a non-gendered voice. Her writing on love, for example, does not inscribe or describe a solely female experience: her concern is for a more collective reckoning with loss and impossible desire. At the end of the section marking the phantom's tenth appearance, Germain writes: 'There in the filth and cold she was silently weeping for the pain of lovers who are no longer loved'.

Once again a comparison with the work of Duras appears appropriate. In her filmscript *Hiroshima mon amour* Duras explores in charged and exemplary terms the re-animation and re-definition of love in a displaced location. In Germain's Prague, empty words of love are written literally on the walls and bridges of the city, as she remarks: 'Under the vault of the bridge graffiti proclaimed the vows of adolescent love'. Beyond and behind real locations both Duras and Germain

delineate the structures and confines of a metaphorical city formed (in Germain's words) 'in the mysterious geographies of anticipation and desiring thought'. This is a city of memory and desire, illuminated, for Germain, in the appearances of the weeping phantom.

In its closing sequences *The Weeping Woman* focuses specifically on the interplay between presence and absence which has been at the heart of the narrative. In the phantom's last appearance Germain writes: 'she reappeared. Only to disappear again for good. It was a silent farewell, and very brief'. The phantom appears to be marked not so much by her appearances as by her departures. Yet she takes on always a virtual reality, as Germain comments again: 'To me she reveals herself only by her absence'. Germain concludes that 'quite simply, it is the book she has left. Not the city, but the book'. She leaves us once again with the phantom as textual product: the weeping woman is seen in the end as the product of the text which has in a sense been created to follow her very itinerary. Germain sets in play the type of paradox and illusion Duras creates in her novel *The Ravishing of Lol V. Stein* – a book Germain admits she admires – where the reader follows Lol's obsessive trajectory through the text, only to find that Lol is herself a product of our fantasy as we read.

In *The Weeping Woman* Germain leads her reader on an illusory journey. She calls up a series of hallucinatory apparitions before our eyes; as the phantom appears in each location, in her diaphanous presence we are shown traces of meaning. Germain seeks multiplicity in a text of fragments and allusions. Her treatment of themes is glancing and suggestive: she calls on her reader to perceive a series of associations and patterns which are both poetic and astutely revealing.

Germain's work has been acclaimed for its dazzling use of language. Her novel *The Book of Nights* was the first

winner of the Prix Grevisse, set up in 1986 to mark the fiftieth anniversary of the invaluable French grammar manual *Le Bon usage*, and intended for a work of literature with the most remarkable stylistic qualities and subtle use of the French language. Notably, also, Germain's work has frequently been compared to magic realist writing and she has been placed somewhere between Gabriel Garcia Marquez and Angela Carter. This appears, indeed, an apt reflection of the qualities of this first novel, *The Book of Nights*, which was published by Dedalus in 1992. What the subsequent, and urgently called for, publication in English of Germain's later texts will also show is that her more recent works have further and differing obsessions, and she is only now beginning to reveal the full, and remarkable, range of her skills as a novelist. I have been trying to stress here that Germain's work is concerned to meditate on the textual, and that she is fast becoming recognised as a writer of postmodernist fictions. Germain writes in *The Weeping Woman*: 'texts too are places ... places where solitude and absence light up'. Germain has developed her own range of textual spaces in which she admirably demonstrates the power of her questioning of the novel form, and her interest in finding a physical correlative and literal metaphors for the dramas of her imagination.

Her first novel is a book of water and of the waterways of France, detailing the generations of the Péniel family through almost a century of passion and trauma. The novel is carefully structured into five 'nights': water, earth, roses, blood and ashes. Despite this order and coherence, the novel possesses also an impulsive free-flowing quality, its plot taking on the proportions of a bizarre and ever extended imaginary game. In an interview in *Le Monde* in 1985 Germain tells in some detail how the novel came to be written. She had sent some short stories to Gallimard which were turned down. Impressed by these, nevertheless, the

novelist and editor Roger Grenier asked Germain to produce a novel, which she went on to write in a matter of months. Germain speaks, in typically modest terms, of the ease with which the novel was written. She comments that her characters seemed to be created spontaneously, that she felt her novel to be dictated by their actions and herself to be entirely consumed by her created figures.

This air of unassuming mysticism surrounds both Germain's work and her working methods. She claims to work only at night, describing herself closing her shutters at the end of the week to find the darkness she needs to write. In this sense the title *The Book of Nights* comes to describe its own conditions of writing as well as its form and subject matter.

Appropriately Germain's work moves from *The Book of Nights* and *Night of Amber*, its sequel published in France in 1987, to *Days of Anger* which appeared in 1989 and won the Prix Fémina.

Days of Anger, like *The Book of Nights*, takes place in the depths of rural France, but this time in the forests of the Morvan, amongst interwoven families of woodcutters. Again Germain creates a novel of poetry and madness. She details a woman's fanatical love of the Virgin Mary, a man's obsession with the dough-like flesh of his vast, adored wife. This love led into realms of near insanity takes its most savage form in the body of the murdered Catherine Corvol, killed as much out of love as anger. Germain reveals the very strengths of her powers as writer of passion and violence in the scene of the murder, where the narrative shadows the thoughts, the incomprehension and the desire of the murderer, not his victim. Germain gives to the scene an intense unreality, its events taking on a ricocheting irrationality, as the warm, sickening blood is spilt almost without the murderer's volition.

Equal in its emotive force, but more sombre in its tone is

Germain's later *The Medusa Child*, published in France in 1991. Here, Germain, in another mythic text, focuses on the painful realities of child abuse. With unstinting realism, indeed, she traces the transformations in her small heroine Lucie Daubigné as she falls victim to her half-brother's passions. Like Michel Tournier's *The Erlking*, Germain's novel animates a contemporary fairy tale of a child prey to an ogre. Where Germain's novel differs from Tournier's, however, is in her stark refusal to angelize or indulge in provocative description. Her text does not ignore the desire of the adult for the child and she dwells even with possible compassion on the brother's torment and his hunger for a 'frail child's body'. Yet the desecration of that child's body and the inescapable horror of the menacing threat within the family are described all the more forcefully in a novel which becomes a book of anger.

The Medusa Child reveals the development and full flourishing of Germain as novelist. It is again a tightly written novel organised in five discrete sections: Enfance, Lumière, Vigiles, Appels, Patience. These almost liturgical parts are then themselves divided, partly into a series of more abstract descriptive passages: Enluminures, Sanguines, Sépias, Fusains, Fresques. These titles, alluding to the visual arts, aptly name these sections of lyricism and great visual beauty. Germain has taken Virginia Woolf's novel *The Waves* as her model, and spaced out her text with evocations of the sky, the horizon and the play of light. Her charged subject matter is modified, and set in relief, by these interludes of distancing: Germain's world is held still in a series of visual images, seeming apparitions. In many ways *The Medusa Child* looks forward to *The Weeping Woman* which followed it a year later. In the earlier novel Germain looks not at the geography of the city (the book is set in the countryside of the Berry), but at the geography of the sky. Germain creates a child astronomer, Louis-Félix, who lives in a

world of astral and celestial landscapes, and finds in the sky his own book of images.

Germain's novels are carefully related one to another, depending on a series of internal reflections as well as intertextual allusions. The reader enters an unusual and compulsive fictional world whose characters take on almost mythic status. Sylvie Germain is one of the foremost novelists currently writing in French and she has achieved ample critical acclaim and many accolades for her novels. It is less than a decade since her first novel appeared, yet she has already defined a style, subjects and forms that are entirely her own. As Germain turns forty next year, her readers can only look forward to what the next decade of her work will hold.

<div style="text-align: right;">Emma Wilson, Cambridge 1993</div>

'What need could I have of a water clock—
we have long measured the years in tears;
to invite an angel home would be a marvellous thing,
but it would be unbearable if the angel were to invite us'.

<div style="text-align: right;">Vladimir Holan</div>

Prologue

I

She entered the book. She entered the pages of the book as a vagrant steals into an empty house, or a deserted garden.

She entered suddenly. But she had been circling the book for years. She would brush against it – though it did not yet exist – she would leaf through its unwritten pages, and some days she even made its blank, expectant pages rustle faintly.

The taste of ink would rise beneath her step.

* * *

She slipped into the book. She edged into the pages as a dream visits a sleeper, unfurling within his sleep.

She may go anywhere and everywhere, gaining entrance wherever she chooses; she sails through walls as easily as through tree-trunks or the piers of bridges. No material is an obstacle for her, neither stones, nor iron, nor wood, nor steel can impede her progress or hold back her step. For her, all matter has the fluidity of water.

She walks straight ahead without ever turning back. Her movements seem dictated by sudden secret needs, and her sense of direction is quite baffling. She may stand stock still in the middle of an empty street, or cut across without apparent reason, having perceived a sound inaudible to any other ear: the beating of a heart heavy with too much loneliness, or pain, or fear, somewhere in a room, a kitchen or a passing tram.

Often it is a human heart long dead that has attracted and diverted her. She moves among the dead as much as

among the living, her hearing perceives the slightest breath, the furthest echo.

The colour of ink, endlessly dried and then fresh again, has always glistened in her wake.

* * *

She swept into this book. That is how she always proceeds: like the wind.

She looms up without warning, at times and places where she is least expected. Then she claims the attention of all, making her way heedless of the astonishment she causes, the alarm she arouses. Perhaps she is unaware she has been seen.

She goes her way and never turns around. But none could say where that path is leading, what compels her steps, what drives her so. She passes like a stray dog, a vagrant, like dead leaves carried by the wind.

The wind – the wind of ink – rises at her passing and blows beneath her step.

Made purely of her footsteps, this book too proceeds by chance.

2

But what is chance? It is confused sometimes with luck, sometimes with ill-luck; ideas of risk, of doubt, of danger and of venture are connected to it. The notion of chance is fluid and evasive, one must be careful with it.

The chance which prevails at the manifestations of this strange wanderer, which guides her steps as she sweeps through bricks and mortar, has nothing of the fortuitous about it, still less anything of the random. This wandering woman has such gravitas, such patience and endurance in her roaming, and there is such power in her fleeting appearances.

For when she does appear, she fills the space of all the visible, compelling attention from all eyes, from all senses, sowing alarm in people's hearts.

* * *

Indeed, it is only the writing of this text which gropes and fumbles, which tacks aimlessly for lack of any sense of a whole, of any certain landmark. Yet how can one chart the movements of an unknown woman who appears in the realm of the visible only intermittently?

The wind of ink which blows in her footsteps makes the words bend and bow, it drags up images which had been sunk in memory at the very limits of forgetfulness, and it leafs in anticipation through the pages of the book which cannot but be fragmentary, and unfinished.

3

Who is this unknown woman?

A vision, herself a bearer and sower of visions.

A vision niggardly with her appearances, which have been rare, and always very brief. But each time her presence was intense.

A vision linked to a place, emanating from the stones of a city. Her city – Prague. She has never appeared anywhere else, though it is certainly within her power to do so.

* * *

This woman has neither name, nor age, nor face. Or if she has, she keeps them hidden.

Her body is majestic, and disturbing. She is immense, a giantess; and she has a strong limp. Her left leg is much shorter than her right. She lifts her feet with effort as though they were immensely heavy, but she treads with even greater effort, as though, once in contact with the ground, they suddenly became extremely vulnerable.

Her clothes are simple, badly cut and of coarse cloth. Her massive, awkward frame is bundled rather than clothed in its lengths of hessian, or hemp. It is as though she had hacked her thigh-length cloak from some bit of tarpaulin tugged from some piece of scaffolding.

There is so much scaffolding running along the housefronts; the stanchions are rusting, grass grows at their base. Some alleyways are entirely roofed in under these rough structures of corroded metal and mouldering wood.

Light is barred from them; shadow stagnates under the gangplanks, seems to drift there, gradually to solidify. Birds roost on the crosspieces with their ill-fitting battens, amidst

the debris of masonry or plaster fallen from the pediments of the houses.

Her long dress is of sackcloth. The shadows of its folds are darkest brown. But its weave is so bare that anything may catch upon it; the hem is fraying and trails over the paving stones, matted with dust and mud.

The woman has no care for how she looks.

She is like those whose hearts have been laid too bare and left too long uncomforted. Nothing can any longer clothe those whose hearts lie in darkness, whose thoughts catch as they walk deserted streets.

<p style="text-align:center">* * *</p>

Although she is huge and cumbersome, and limps badly, this woman makes no noise as she walks.

Her steps are silent, but her body whispers like the wind: as though some small gust were caught in the folds of her garment, a faint whisper of ink; or is it tears?

Chronicles of her appearances

First appearance

'Who is pacing up and down at the threshold,
whose steps are those which murmur in my soul,
whose approaching solitude do they foretell,
who come here, who am I questioning?
I see no one'.

<div style="text-align: right;">Bohuslav Reynek</div>

The first time she appeared was on an autumn evening, in an alleyway in the old town. A fine rain was falling. The bitter smell of must and rotten wood from the old scaffolding, abandoned along the houses, mingled with the smell of the fog.

In Prague, from the end of autumn and throughout the winter, the mist has a smell, and even a texture. Some evenings it is almost palpable, it is so thick and yellowish. The smoke from the city swells and colours the mist, the lignite dust floats in the air with a bitter-sweet taste. Cities, like bodies, have their smell, their skin.

The giant-woman was limping down the alley, haloed with blue-green light. Had she just come out from a porte-cochère masked by the scaffolding? Her head, wrapped in an off-white linen shawl, brushed up against the first level of the walkways. A wide brown hood hung from the nape of her neck. Her head was high.

She always holds her head high.

It seemed as though she must knock into the uprights which supported the walkways, already all askew; that she was about to send them tumbling down; she rolled so as she walked, and her shoulders were so broad. But she scarcely touched the slender stanchions. The pitch of her great body is always very gentle.

She walked serenely in the twilight fog. The faint glow of the streetlamps altered the colour of her clothing. Everything took on a greenish tint, vaguely chilling, like an aquarium lit with neon. The tall tin dustbins which lined the streets glinted silvery-bright.

She was walking in front of me, a few metres ahead. I followed her at a steady pace.

At the time of that first appearance the idea that she was actually an apparition never occurred to me. And when the giant-woman disappeared as suddenly as she had come, surprise did not yield to amazement as it does at the witnessing of some marvel. There were so many corners looped with shadow, so many doors in the recesses of the house fronts, so much fog – the giant-woman could have vanished from my sight simply by moving out of the frail shaft of light flickering down the middle of the alleyway.

* * *

No, my surprise was of another kind. It had to do with the mystery of enchantment, not with the workings of curiosity.

That surprise was just dawning, it was still unconscious. It was lying dormant in the shadowlands of a nascent dream.

It was the vaguest stirring of the heart.

Second appearance

'The mist shifts
like the scales for weighing the souls of the dead.
Everything is growing, everything is at hand.
An angel forges the last trump
in a clamour of expectation.'

<div style="text-align: right;">Bohuslav Reynek</div>

The second time, I really only glimpsed her. Again it was in a part of the old town. The fog was even denser than on that first occasion, evening had not yet fallen, the streetlights were not yet lit. But the wan, greyish light could not really have been called daylight. The sky hung so low, it seemed to graze the rooftops. There were no lights. The mist had corroded the daylight.

The wrought-iron grilles around the coping of the well in the Lesser Town Square were scarcely visible, as though the fountain were giving out nothing more than a wave of milky liquid which spread about it in broad scrolls and wove around the few passers-by, blurring their outlines. But I recognised her immediately, because of her height and her limp. She pitched gently, veiled in fumaroles. She was on the point of leaving.

She always has an air of someone on their way, someone who is going for good; yet each time she appears, she steps right in before the witness to her appearance. She moves through sight and memory back to front.

By the time I had seen and recognised her, she was gone.

* * *

That time too, it would have been hard to guess who she was. That day, in the opalescent mist, all the passers-by looked like ghosts who had mislaid their fleshly bodies.

On the Old Town Square, just nearby, the long silhouette of Jan Hus emerged fleetingly on the prow of his bronze pyre. The belfry, the twin towers of the Tyn Church, the dome of the St Nicholas Church, had all melted away. The whole of the Old Town Square had been razed. Some November days are like that – the visible world founders.

Thus there was nothing strange in the giant-woman weaving and vanishing, lost in the fog. She was one more shipwreck among so many others on that misty late-autumn afternoon.

<p style="text-align:center">* * *</p>

But the surprise of seeing her again was already gathering disturbing momentum; it brought about the same faint stirring of the heart as it had done the first time.

Third appearance

'Even someone who is completely abandoned
by humans, by ghosts, by things and animals,
even someone who talks to himself
is not talking for himself alone!'

 Vladimir Holan

Her next appearance was one morning towards the end of winter. There was no fog that day. The sky was the colour of lapis lazuli, the air was clear and cold. It was in the Zizkov district, on a long street not far from the Olsany cemeteries. Grey drifts lined the pavements and the gutters were full of dingy snow. Brilliant patches of glazed ice broke up the darkness of the ground.

The giant-woman was walking in the middle of the pavement.

* * *

She was limping along in silence, as when she had appeared in the alleyway in the watery light of the streetlamps, or when she had come out on to the misty little square last autumn. Her body, apparently so heavy and unwieldy, in fact moved quite nimbly, without disturbing anything, and her lame feet made no sound on the paving stones or asphalt. So massive and billowing, she trod as softly as a cat. She was even more delicate than a cat, for she left no mark on the muddy snow which dirtied the pavement.

She made no sound and left no trace; yet if you listened carefully, you sensed a slight rustle in her wake, perhaps made by her trailing dress, by her loose cloak, or by a constant whispering beneath her veil.

But almost immediately you saw that it was not the rustle of material, nor any constant whispering.

It was like the noise of water – but so low, so slight. It was like the murmur of an underground spring, of water locked in the depths of swallowholes, in the cold half-light: invisible waters trickling in the recesses of ancient rocks, which set up strange echoes in the immensity of that silence and emptiness.

It was a low keening, a restrained sob of infinite softness. What grief was weeping within her?

For it was as though something were crying within her, and not as though she herself were shedding tears. Perhaps indeed she was not crying at all. The watery murmur welled up from within her body, as though the voiceless sound of the blood which flows in the flesh had been made perceptible. Was that the sound of her heart? Was it the inner throb of her flesh, or the flinching of her skin? But caused by what suffering?

* * *

As I was almost brushing up against her, having quickened my step so as to pass her and catch a glimpse of her face, I had a sudden insight, which caused me to abandon my curiosity: that woman had no face of her own, she was not even a single person, an individual – she was a plural being. Her body was a place of confluence for innumerable whisperings that had come from other bodies.

Who then was weeping in her?

* * *

For it was not she, not she alone who was groaning and weeping in this way. It was the whole city, and its outskirts, and beyond. It was the earth, that of the living and the dead.

This woman with the awkward gait, with the monumental girth, was not made of flesh and blood – but of tears. She was not born of woman, but of the grief of all men and women.

This wanderer dressed in old cloth the colour of mud and of saltpetre, was the emanation of a common grief. The manifold sorrows of mourning, desertion and betrayal had given birth to this being, disembodied but intermittently visible.

She was the most beggarly, the most deprived being imaginable. She had nothing of her own, not even her body or her tears.

And she had to walk, endlessly, at the extreme margins of the visible; most often, in invisibility.

* * *

That is what I realised, that morning with the lapis lazuli sky streaked with clouds of dazzling whiteness, around Orsany, when I very nearly brushed up against her and was preparing to pass her, to see her face at last: I realized that the woman was of no particular race, that no blood ran through her insubstantial body, that she was an unfinished being, infinitely wretched and subject to weeping. A being endlessly on the verge of entering life, and endlessly on the verge of leaving it.

But this incorporeal being was in no sense an hallucination; she was a vision arising from some mysterious condensation of the tears and sufferings of men and women, and children too, trapped in the meshes of misfortune.

She was like the rainbows which appear hovering around a waterfall after rain or in fine drizzle, an incorporeal and transient beauty born of the refraction of light rays in raindrops.

She was like those short-lived crystals of snow or hoar-frost, which melt the moment they are touched.

She was like the great haloes (sometimes palest white, sometimes brilliantly iridescent) which gleam around the sun and moon; those rings of light formed in distant, frozen mists shot through by the sun's rays.

Such is this woman, incorporeal yet briefly visible.

* * *

Her visibility is not just rare and fleeting: more importantly, it is partial and oblique. You cannot, you must not look this

woman in the face. Just as you must not look at a solar eclipse without smoked glass, unless you wish to see nothing but shadows from then on.

To look this woman in the eye would mean darkness for the heart, for ever. How, indeed, could you look at human suffering in all its nakedness and not die yourself?

We are vouchsafed the merest glance of this giant-woman, we may follow her, for a brief moment, from some steps away. Nothing more.

She is untouchable, unbeholdable.

Fourth appearance

'Sometimes it happens that the human soul stinks
like the hair of a wet dog.
That is no blasphemy. I just want pain
really to hurt, and for a tear to be a tear.'

<div align="right">Jan Skacel</div>

Months can go by without a sighting. But truth to tell it matters little that her appearances are few and brief, and even that one day they may cease entirely. The fact remains that she is there, in the city, present at all times, although invisible. When they go into eclipse, sun and moon are hidden from our sight, but they do not desert their heavenly mansions.

Sometimes too she may suddenly make herself felt independently of sight or hearing. She may take the form of a faint presence upon the surface of your consciousness, unbeknown to the five senses: as a very slight, very vague stirring of thought, like the least movement of a breeze upon the air – and then you know that she is there. Then, suddenly, memories well up from depths, like water-sprites netted by the imagination to take a turn on earth in nacreous moonlight. Then, like water-sprites streaming with violet and lime-green algae, watered with ooze and silvery scales, fingers ringed with kingcups, these memories step forward timidly.

For a moment you are unsure where they come from – what lake, river or marsh, what chink of memory. They hum quite quietly in their silvery voices – a melancholy echo of voices long since silent. Soon, emboldened by the attention they have won, they begin a round dance, their lovely liquid eyes looking askance beneath half-lowered lashes.

These looks disturb, for they are as shy as they are insistent. Drawn upwards from the depths of water and slime, from the depths of our forgetful memories, these looks beseech daylight and acknowledgement. They come to beg the brightness of the present, a brief time of welcome

in the thoughts and hearts of the living, in order not to be dissolved for ever in indifference and oblivion. They come to cheer themselves at the warmth of the living – yet it is they who warm the living. They bring us their quiet warmth – the warmth of ashes and of dust. Often, the warmth of tears.

For there are tears which, however long since shed, never cease to spread their sense of burning, to well anew upon the surface of the heart.

For there are tears which still flow on, long after the eyes which shed them have been closed.

* * *

It is the tears of the uncomforted which murmur in the great incorporeal body of the weeper of the streets of Prague; and these uncomforted are both living and dead.

* * *

The weeping woman limps endlessly between two worlds: the visible and the invisible, the present and the past, the living and the silent. She weaves from one world to another – a clandestine frontier-runner of mingled tears, those of the dead and those of the living.

* * *

Thus one day, as I was walking down a street in Mala Strana, past a deserted house with broken windows, its facade blackened and dilapidated, its entrance littered with rubble, I sensed a faint snarling sound. It was the wind stalking through the upstairs rooms, slithering along the walls, clambering over the half-collapsed floors. As it gusted, it shook the shreds of tattered wallpaper and lifted the pages of some old newspapers strewn over the floor. The wind whistled, the wallpaper stirred, quite gently. The condemned house was breathing a last breath, heaving a final sigh.

Then suddenly these murmurings and rustlings took on shape: they were the breathing of a man long dead. Of a man who, during his life-time, had written letters by the hundred, had painted, drawn and engraved, had written books. Dazzling books, for this man, a sower and engraver of signs, was a seer.

He was an unobtrusive man, puny with great eyes and a restless heart.

He was killed by a bullet in the back, in broad daylight; he fell without making the slightest noise. He was so light, so vulnerable. As gentle as his name: Bruno Schulz.

He had created a vast oeuvre of magical beauty with his unfurled visions, his eddies of desire, his incantatory obsessions. But little remained of all these images and words. Of his correspondence, voluminous as it was, only a few random letters have been found. These letters were lying around in deserted, ransacked houses. Many of their recipients were gunned down as he himself had been. In camps, in forests, in ghettoes. Many of his letters burned during the Warsaw uprising.

And suddenly, for a moment, all those letters – vanished, burnt, lost – had drawn breath, taken voice. Those letters were murmuring, as though the voice of the man who had written them, and the voices of all those who had read them, had been snatched from silence and forgetfulness and had foregathered in that place, in a district of Prague, half a century later.

Perhaps our world is full of voices, of the breath, the whisperings of ink, the sound of footsteps – inaudible murmurs which brush against us without our knowing, without our sensing it. And these murmurings are so slight that they flutter in the air, drift upon the wind, cross plains, rivers, forests, towns and mountains. They mingle with the rain, the hazy sun, the snow and the drizzle. They are all around us, in the air. But like the dust suspended in the air

we breathe, unseen until a ray of light reveals it, these murmurs too become vaguely, fleetingly perceptible only thanks to some frail movement of silence at the heart of the noise which surrounds us always.

That is what happened that day. All that was needed was a gust of wind in an empty upstairs room in a ruined house for those dead voices, gathered like a heap of dead leaves, suddenly to start to whisper, and for the moment to expand and burst, allowing a constellation of past moments to descend upon the extreme rim of the present; voices silent for half a century, lost words, burnt throughout war-torn Europe, to begin to hum, in that place, though it had not been intended for them.

And it was she – the giant-woman, the weeper of the streets of Prague – who had revived those ancient voices, those broken words. Although she was not visible that day, her presence was quite apparent. She had passed through the wall of the empty house just before I reached it, and the wind had found its voice beneath the steps of her invisible presence. The voice of Bruno Schulz, the son who loved too much and took to his bed for six months, near the bed where his father was dying, and who, when his father died at last, began his ten-year wanderings from town to town, from train to train.

The voice of Bruno Schulz, the little man with nerves so fragile that they sometimes spread like a vast cobweb throughout the studio where he taught, stretching from floor to ceiling, covering the walls; and the children's shouting made those raw, proliferating nerves flinch with pain and anger.

The voice of Bruno Schulz who never ceased to ask for help, advice, a little recognition and encouragement from the recipients of his letters.

The voice of Bruno Schulz, half ogre half Tom Thumb, whose eyes fed eagerly upon the visible world, its flesh and

lustre – the dazzling lustre of women with the feet of idols. Whose eyes fell prey to visions legendary.

The plaintive voice of Bruno Schulz, filled with dread by the mere sight of a tall factory chimney rising above a small yard.

The voice stolen from the mild Bruno Schulz, who was shot in the back because he had gone out into the street without his yellow star. But that day, it is said, he had a loaf of bread under his arm.

It was a time when certain men had ordered other men to wear a star, nothing but a star, to the exclusion of all else, even their very names. It was a time when the human soul truly stank like the hair of a wet, flea-ridden dog. But that time is by no means over, it will never cease to be.

He was bearing a loaf of bread, and he was walking in the streets of his native town, Drohobycz – the magic city of his childhood which became sometimes a hothouse filled with exuberant flowers, with fruits of paradise and wild grasses, sometimes a Biblical desert where the figure of his father, a patriarch prey to all manner of metamorphoses, stood out in flame. Drohobycz, the very essence of his enchanted boyhood, a dense labyrinth aglow with desires, with fears and dreams, and finally a ghetto, where death awaited him.

* * *

The bread, which fell with the man who carried it, still rolls along the streets of Drohobycz. It will roll until the end of time, in dust and blood.

And the weeping woman, whose heart is open to all winds, all sounds of keening and all human tears, picked up – not the bread, but its taste of dust and blood.

* * *

The wind soughed in the deserted house, and it had the smell of dried ink, old paper and bread sodden with blood.

The musty smell of millions and millions of stars that had been hurled against the earth, whose light had been trampled out; or musty smells of souls as sickening as the hair of a muddy dog.

Because, under all its fine airs, History stinks. It has to be smelt, so that we may know how much the pain of the victim truly hurts and that no one may remain ignorant of the gigantic weight of a single tear.

Fifth appearance

'Night falls as though for ever in the shadow of the town. You see the crepe of sorrow flutter on the house fronts.'

<div style="text-align: right">Jiri Karakek Ze Lvovic</div>

It was one evening in May. The lilacs were in bloom. Long streaks of pinkish cloud hung in the sky above Petrin; the air was mild, full of scents, and there was an unusual buoyancy in the steps of the passers-by – a touch of light on the women's eyelids, a smile around their lips. People were sauntering. Children were lingering in the streets and gardens, playing ball.

In a street in the Vyton district, three young boys were playing with old tennis balls, lobbing them against a wall. The balls flew upwards, struck the blackened roughcast with a dull sound and fell down again; and the boys leapt to meet them, catching the balls in mid-flight, before throwing them up again. It was as though they were performing an important task, rather than playing, their movements were so tense, their expressions so serious. They ran and jumped as though their very lives, their freedom, depended upon it, endlessly renewing the supple upsurge of the balls. At that moment, their childhood was at stake.

In the boys' hands the spinning balls became transformed: those bouncing, greyish little globes became true spheres – miniature planets struggling against gravity, drunk with momentum, thrust and height. Minuscule planets, centres of gravity for the pure desires of childhood.

Their eyes were sparkling with both joy and carefulness, with gravity and dreams; and it was their very hearts that were leaping there.

* * *

It was one evening in May, in the Vyton district. Beer-drinkers were talking loudly at the door of an inn on the corner of two streets, and laughing. Tireless orators drawing

their taste for words, their story-tellers' tones, from their enormous mugs. Their voices mingled with the cries of seagulls and the jangling of the trams along the embankments. Dogwalkers stopped to chat among themselves, or to others from the neighbourhood who had come down in their slippers to the inn to buy beer, which they carried out in large earthenware jugs. Men and dogs seemed to take pleasure in sniffing the evening air, savouring each moment languidly.

A little higher up, at the foot of the ramparts of the Na Slovanech convent on a small mound planted with white and purple lilacs, the giant-woman appeared.

She was standing among the trees, half-hidden by the branches. Only the skirts of her dress were visible. She almost blended in with the purplish shadow of the grove.

She held herself very erect, and still, one hand resting upon a trunk.

* * *

All the visible world was focussed upon her, the noise of the neighbourhood and the river dwindled. The sweet, heady scent of the lilac at sunset suddenly mingled with the scent of the body of the giant-woman. Her body of tears and memory.

Almost imperceptibly, the breeze which cradled the branches, heavy with their flower-bundles, began to murmur the words of a poem written by a child.

> 'The little rose-filled garden
> smells so sweet,
> its path so narrow,
> where a little boy walks,
> A tiny boy, pretty
> as a unfolding rosebud.
> By the time the bud is out,
> the little boy will be dead'

Almost imperceptibly, the breeze murmured the words of this poem written by a little boy in Terezin, long dead. By a little boy who never became a man, but was consigned to ashes, wind, the grave and oblivion.

The breeze murmured this oblivion, lingered upon it.

The body of the giant-woman had dissolved into the shadow, into the smell of the lilac, into the softness of the evening. The body of the giant-woman had faded away, carried off by the breeze; becoming one with it.

The body of the giant-woman floated on the evening air. The voice of the long-dead child as pretty as an unfolding rosebud climbed wandering along the streets. It was a voice for ever in the throes of death and seeking comfort.

> 'The little rose-filled garden
> smells so sweet,
> its path so narrow . . .'

The little boy was called Franta Bass. Another, nameless child from the camp at Terezin, also used simple words to tell of the beauty of the earth and of its flowering; a beauty which he was denied.

'All the trees are flowering, and it is so very lovely, even with their great woody age, that I am afraid I may never be able to lift my eyes towards the tops of their great green beauty'.

The May evening was lovely, tender and sweet-smelling, but an old grief spoke within it, making people lower their eyes in shame. The lilacs flowered upon the memory of dead children, the eyes of all the children of Terezin, closed at the threshold of the beauty of the world.

Sixth appearance

'My body is like a little boat,
I am drowning in this ocean,
as though emprisoned in the storm,
my boat is already breaking up.
Oh how often my tears implore you!'
 Bedrich Bridel

Sometimes in summer, in the late afternoon, the sky will become suddenly leaden, slate-blue and steel-grey, and the light become strangely intense. The sky is lowering, the light is violent, while the birds fly low. A storm is approaching. You can hear the rumble of thunder. But the rain does not come. The storm is imminent, threatening, encircling the town; you hear resounding drumrolls, great cracklings, but the storm does not break. The wind howls, bending the trees double.

Nothing happens. Only this dazzling, shale-blue sky, this crackling; only the birds too frightened to take wing, and the whipping wind. Only a sudden, yet indefinite, period of waiting.

It was that sort of day. While I was crossing Chorvatska street at Vinohrady, I saw the giant-woman; she was half-way up the sloping street. Below, the district of Vrsobicc seemed sunk in shadow.

She was walking briskly despite her limp. Her great body plunged leftwards, then seesawed back towards the right with its regular pitching. Her tall silhouette stood out clearly against the background of the stormy sky, where a shaft of pale blue had just opened up. The wind sent her long rags flapping and drove the bits of newspaper strewn over the pavement briskly before it.

But something was wrong: however hard you looked, it was impossible to tell whether the giant-woman was moving forwards or back, whether she was going up the street or down it. Yet she was walking.

Perhaps she was just treading the wind.

* * *

No whispering sound came from her. The wind was too strong, rising above all other sounds.

She walked and walked. She was walking in two directions at once. Time gave way beneath her step.

Suddenly time *was* that sloping street. Time *was* that street which dipped down towards a low-lying area of the storm-beleaguered city. Time *was* that street stretched like a tight-rope above an abyss. The past was striding forwards – but it was going so fast that it was also the future.

There is no such thing as time in the abstract: time is always the time of a body which feels and bears it, the time of the history of a living person. And it turned out – in that brief flash of an instant, the colour of bluish soot – to be the time of a man who was at that moment lying on a bed a thousand kilometres away, his body broken by illness.

All that man's suffering swept into that street, was reflected in the metallic sky and lowed in the wind. All that man's silent bed-ridden struggle – nailed as he was between two sheets – became manifest in that empty street. His gentle eyes, his soft, patient expression, rose up there in the street. The paving-stones were his eyes, and looked upon the vastness of the sky, resplendent with its bluish shadows. And his face – innocent of all ugliness, anger or hatred or untruth – was suddenly wrested from the folds of the dress of the limping giant-woman.

This face was wrested from the dusty folds of her wind-blown dress, and began to float and drift upon the air like a kite. His wide eyes looked sad and tender.

My father's hazel eyes.

My father's eyes which, for months, had had only a stretch of sky to look upon; a stretch of sky the size of the window opposite his bed. A stretch of sky in Auteuil, in Paris.

* * *

The giant-woman disappeared, carried off by the wind, sucked up into the shaft of blue on the horizon, or perhaps transformed into that face which had just risen up from the folds of her garments.

The face of my father faded away, vanished in silence beyond the roof tops.

The storm moved off; its rumblings became fainter and died away. Nothing had happened. Only a short suspension of time, a brief and very short-lived incarnation of time through the face of a man bed-ridden, but so far away: in Auteuil, in Paris.

* * *

And now that my father is no more, that time has bested him, and he no longer lies on a bed of pain, but in the earth, becoming disembodied, falling apart in the dark and chill earth, his face turning to dust – the image of this man's face, the sound of his breath, of his voice, of his footsteps, remains.

His face rises forever, in every sky. Dream or daydream, it shines through suddenly, astonished at no longer being of this earth.

Everything lives on in the folds of the dress of the disembodied giant-woman, in her invisible weeper's tears. For when she sows the vision of a face as she passes, or the echo of a voice, it is not to cast them off, to have done with their memories; on the contrary, it is to revive this memory, to give it back the colours of the present – to make it live like a newborn heart. And when, after her brief appearance, she is gone, and the vision or the echo she has aroused fades in its turn, she does not abandon the briefly rekindled memory – she takes it back, buries it once again in the folds of her dress, and rocks it with even greater tenderness to the rhythm of her walk.

Her long, pilgrim's walk through the streets of her city, through the density of time.

Seventh appearance

'The tear upon your eyelashes
shatters the curse upon the roofs
all that weighs upon my heart;
yet it was for you I wished for song'.
 Jaroslav Seifert

In the folds of her garments, the colour of earth and masonry, the lame giant-woman, the weeper of the streets of Prague carries faces and voices in their thousands.

She conceals so many names in the folds of her fraying dress that they could form a whole people; like the names carved on the walls of war memorials.

She keeps in mind the timbre of all the voices which murmur in those dark folds, to emerge and escape from them at times, one by one, like bees leaving a swarm to go off and fly around in the light of day.

She knows the faces of all those beings intimately, she can put faces to all those voices and names.

But she is not a spectre, a fossilization of the past. Nor is she a prophetess. She foretells nothing.

She is the face of time, which passes and slips away and disappears, and marches on ceaselessly into the light of day, and ceaselessly into shadow, into mist, which sinks into night then rises again with the day. She is the mysterious tremor which runs over the face of time – a tremor of weariness, emotion, tenderness or pain. But never of anger.

Never, during her appearances, has there been the slightest suggestion of violence.

She is the face of time – of the time of men. The tender and vulnerable surface of their faces. The face of the human heart.

She is the infinitely gentle face of compassion which runs over this face, as vast as the world and as long as History.

Perhaps she is the distant echo of the pity of God: that immense and unceasing pity which beseeches that its sad call be heard and heeded in the world. That immanent pity which runs through History limping behind the perpetual

din of wars, crimes and all spilt blood. But she is hounded everywhere, man can do nothing but add to her sorrow, to the darkness and blood and tears in the folds of her tattered dress.

Yet she never wearies of calling for pity for each and every one.

* * *

One evening she appeared as she had never appeared before. She was sitting on the side of the hill of Vysehrad. Her size and bulk were no longer just those of a giant-woman, but of a truly vast and strange colossus whose outline was transparent and apparently without strength. Her body had the translucence of glass, or lava. The light and shade of evening shone right through it.

She was sitting there, her hands on her heavy parted knees like a peasant woman's, catching a moment's rest at nightfall on a bank beside a field. The city and its dawning lights were spread out at her feet.

Motionless, she sat enthroned in humble majesty. Suddenly she leant slightly forward, opened her arms and held them out towards the city, as though she were inviting the whole city to come and sleep upon her knee, to come and rest in her arms.

Gently she picked the city up. She lifted it as a mother does her child, and put it on her knee to cradle it. Then the mournful voices of the loudspeakers of Smichov station, announcing train departures and arrivals from the other side of the river, began to hum a cradle song. The station loudspeakers spread the giant's murmured song throughout the evening. And for a moment the noise of the city became as slight as the breath of a sleeping child, and the river which streamed between the arms of the giant-woman took on the brightness of a tear shining on the lashes of a child who has been calmed and comforted after some great

unhappiness. The swans and ducks, clustering together along the river's edge, slipped their heads under their wings. And the reflection of the bridges in the water brightened until they became milky, while the jangling of the trams rang out in silvery chimes which seemed to come from the first stars.

For a moment – just a moment – the whole town was cradled upon the giant-woman's knees, lapped in her arms and rocked by the song that rose from her womb of earth and roots, from the heart ringing with tears that tasted of milk.

For one moment – one marvellous moment – the city was unburdened of its century of lead and dirt and blood, reliving the bright dream of its beginnings; it remembered that legendary day when princess Libuse foretold its coming glory.

* * *

Did she sink into the rocky hillside or did she move off in the direction of Podoli? Suddenly the giant-woman was no longer there. The city had returned to its normal seat, its everyday life, with its noise and twinkling lights.

Perhaps the giant-woman had slipped into the train which was just then rumbling over the iron bridge with a sonorous grinding, splashing the river with squares of pale light. The loudspeakers from Smichov station announced the departure of a train for Plzen, Stribro, Marianske-Lazne, Cheb.

The city had returned to its sullen, rugged present, to its coarse-grained essence. The city whose splendour and glory had so often been overlaid, and whose freedom and pride had been usurped for decades, fell back into its apathy.

But two years later the city shook off this long and galling torpor, in a first stirring, there on the hill of Vyse-

hrad, which sowed the seeds for its renewal. It was as though the pride which princess Libuse had once felt in her city had been suddenly rekindled.

Eighth appearance

'We are not alone in suffering like this, remember.
Think of all those ruins
of families undone, all those embers dying.
It would not be decent to feel too great a happiness
when God suffers, and when the face of man
has been so soiled'.

<div align="right">Jan Zahradnicek</div>

She does not appear only on streets, borne on the wind and the mist, or the light and the snow. She does not manifest her unforeseeable presence only along the old fronts of deserted houses, in groves of lilacs or on hillsides. She may appear indoors – in rooms, in shops, in cafés.

It was in a furnished room, its walls covered with flowered paper. The paper was already old, faded, grubby and even peeling off in places. The red and orange of the painted roses had darkened, and the background, which must have been a light straw colour, had become grimy. Those dull roses, identical and uniformly spaced, formed a monotonous vertical garden which enclosed the few sticks of wooden furniture.

A gloomy garden in late autumn, when the flowers have lost their brightness and are preparing to die. Graceless, charmless roses, with hardly any scent. Roses that belonged to no one. Vacuous as they were, they gave off an endlessly repeated sense of emptiness, anonymity, and deep boredom. Boredom as deep as forgetfulness.

Seated at a table in this furnished room, I was reading. A metal lamp, painted a dubious eggshell white, cast an oval of light on to the book, and the objects around it striped the cloth with strokes of oblique shadow.

Suddenly I was distracted from my reading. She was there, positioned at the edge of the table, motionless and invisible, but so fully there that it was impossible to feel any doubt as to her presence. Nor did I need to try to detect any visible sign of her, to scan the surrounding space for further confirmation. She was nearer than she had ever been, invisible in her closeness.

She was there, so thoroughly and strangely there, erect in

all her beggar's majesty and silence, humming with a long low murmuring of tears, quite invisible and completely present, a disembodied giant-woman with her merciful heart laid bare.

* * *

As on each of these appearances, she remained only for a moment. But that moment was enough, as it always was, to topple time and place, to transform the whole space of the visible world around her, to deflect thought from its course, and to summon it towards memory. To put fear into the heart and set memory trembling like a body which is cold, hungry and frightened – a real body of flesh and blood and sinews, suddenly awakened within our own.

* * *

She had already gone. Her presence had lasted only as long as the whitening of a wave drawn forwards from the opaque mass of the sea along the sand. Scarcely has it unfurled its curls of foam than the sea calls it back to merge with it once more, and the faint vanished wave leaves nothing on the sand but a slight outline.

It is the same with the giant-woman. That day, the outline she left in her wake was once more that of a face. A faint image appeared on the wall, opposite the table – the ghost of a child's face amidst the roses on the grimy wallpaper, amongst those roses that belonged to no one; those lacklustre roses of forgetfulness.

It was that of a little girl with eyes too large, and dark, for her small, pale, tired face; eyes with lids heavy with cold and hunger, and a lost expression. And her mouth was too big, with its lips parted in hunger, silence and boredom. Her face looked as though it did not know how to smile, and her lips as though they might never have smiled at all. They gave her an expression of near stupor.

Stupor in the face of the world to which she had no access. For this child was so poor that she did not even have any shoes to go off to play in the streets, to walk outside under the sky in the light of day. The cold was so harsh in the unheated basement where she lived, that she had to stay in bed as long as the bitter winter lasted in her village.

For her, his barefoot child, her father had painted flowers on the wall behind the bed which poverty decreed should be her home. Her father had no money to buy her clothes or shoes or milk. He had no money for anything.

The face of this little girl, robbed of her childhood, of the light of day and the love of life, marooned in a bed with dirty sheets at the back of a cold room, was rescued from oblivion by Roman Vishniak. This childish gaze, stupefied by poverty, was immortalised in a photograph. Thus it becomes for ever a shameful wound and a thorn in the History of men; a wound of shame and pain among millions and millions of others. But each wound is unique, and each is raw in the flesh of History.

This little girl was killed, like so many of her race. She was called Sarah. All she was to know of this world was the rough sheets where her puny body shivered, and a few flowers painted on the roughcast wall of her basement lair.

But do those flowers – these illusions of flowers and of the unattainable spring, those underground flowers of hunger – have any less reality than those blossoming on trees or in gardens? For those flowers, far from being illusions, or figments, falsifying the knowledge of the world, are utterly real. Because they flowered beneath the hand of a father who had nothing else to offer his child, beneath the hand of a man whom other men hounded towards poverty, beneath the hand of a living being whom History, once again seduced by the temptation of evil, delivered up to death amidst universal indifference.

Those flowers painted in the gloom of a basement above the bed of a child deprived of everything, those two white flowers which float like a nimbus, sending a halo of holy light over the head of a hungry little girl, are more acutely, intensely, deeply real than the loveliest flowers sprung on earth in the brightness of the day, under the sky.

For those flowers, flowers of the poor, the downcast, snowdrops piercing through stone and hunger, those cloudy cellar-roses have flowered on the face of History, in the shadow of war and hatred, and they continue to bloom, despite the deeds of men; to exhale their smell of cold, sweat, blood and tears in the secret places of men's memories. If it is true that we have memories and leave them behind us.

And the face of History is constantly covered by such flowers, constantly chapped by cankers of shame and injustice, by the eyes and mouths of children gawping like wounds at a world which rejects and murders them. And it has been so on earth since the dawn of time.

The body of History is like that of a drowned man who has long lain on the sea bed, and whose ravaged flesh has become encrusted with all manner of shells, algae, corals and underwater flowers. And the more the flesh is ravaged, the more the shells, the flowers of mother-of-pearl, the accretions of tears and blood, proliferate. The more the flesh is distorted, mutilated, the more myriads of eyes and gaping mouths open in its wounds. For whatever the great and powerful may believe, it is less they who make up History than all the little ones, all those anonymous extras who have endured and suffered History, and died of it, as drowned men die, wrenched both from their abode on earth, and from the freedom of the sky, the light and the wind.

* * *

How should the giant-woman not limp, she who has to bear so many vanished human bodies in the folds of her garments, the bodies of shipwrecked men and women, of barefooted staring children, century after century? When she has to carry the heavy body of History, from the bowels of the past to the prow of the present?

How could she have a face of her own, or indeed a body of flesh and bone, when her face is made up only of the obliteration of millions of faces and her body only of the sweat and tears of the dead and all the living?

Above all, how could she show herself in the light of day, allow herself to be looked upon full-face and touched, when she is merely a shroud, endlessly woven and rent, endlessly enfolding new bodies of pain?

* * *

The giant-woman had already been gone for some time, and the face of little Sarah had faded, but the silence in the room continued to deepen, and harden. The words of the open book on the table, under the circle of light cast by the eggshell-coloured lamp, no longer made the slightest sense; they had become scratchings of ink on paper.

Sometimes the revelation of an image is enough for language suddenly to glaze over, for thought to snag. We are left untenanted, anchorless, our eyes misted over with absence, our hearts a prey to emptiness. And if death were to come to take us at such moments, it would find no one – just a husk of a being. A husk crackled with astonishment and naked dreams.

Ninth appearance

'Someone was playing the oboe – on and on –
in the shadow on the river bank
with no boats alongside.
Was he just playing casually,
or was he playing to allay his Fear?
Was he a silent Shepherd, or a dispossessed King?'
<div style="text-align: right">Karel Hlavacek</div>

The river water was high. A little upstream of the Sitkovska tower, along the quays once busy with raftsmen, there were big puddles on the paving stones. The river banks were strewn with branches that had been carried down by the current; their swollen bark was greenish-black and their twigs were bare. There were bits of crates, pieces of broken bottle and even a glove.

Seagulls were wheeling above the river, giving occasional shrill cries which cut across the constant peevish cackle of the mallards. The swans manoeuvred slowly and silently over the water, moving sinuously in threes, in couples or alone. They followed regular, restricted courses as though they were trying to follow their own wakes, and when they were tired of their comings and goings they struck out obliquely towards the bank, brushing against the ducks and black coot clustered in little clans in mutual indifference.

The light was fading. A hunched old woman was trotting along the bank, taking care not to get her boots wet in the puddles. She was holding a plastic bag full of crusts of bread. Gravely she distributed her dry manna to the river birds. When her bag was empty she shook it, so that not one crumb should be wasted, then she folded it up and slipped it into her pocket. She stayed another moment to survey the birds that had flocked around her; she seemed so frail beside the big swans, craning their necks and hissing, wings outstretched to push back some rival greedy for the same morsel of stale bread. She talked to the swans as people talk to squabbling children, scolding the greediest, most crotchety ones, with no thought for their powerful wings. Then she trotted off with the slightly hesitant gait of those who have lived too long, and who know that the

human beings who surround them are no longer quite their contemporaries. Their true contemporaries have gone before them into the mystery of the eclipse; they themselves – these old people on the fringes of life – are waiting their turn, throwing bits of stale bread to birds in parks or on riverbanks. Little old Tom Thumbs who no longer do anything but mark out the forlorn, long path of boredom with crusts and crumbs, with sighs and with soliloquies.

A star appeared in the brownish sky, faint and distant. The sounds of the city became muffled, while those of the river became more intense. A long convoy of goods-wagons crossed the railway bridge with a resounding clanking sound, irregular yet strangely comforting. The great containers stowed on the trucks stood out, whitish masses against the darkening sky, in an endless parade of ghostly, identical silhouettes. The star, suspended in the sky high above the city, right above the river, was gaining strength.

* * *

Now another silhouette appeared, single this time. It was that of the giant-woman. She was sitting on the river bank, right by the water. Swans and ducks were sleeping at her feet, their heads deep under their wings as though they were seeking a second layer of darkness in the warmth of their bodies, under the softness of their plumage.

I saw her from behind, from the top of the wooden stairs I had just climbed to reach the overhanging roadway. She was looking at the river, at the reflection of the star in the dark waters. And this time she did not have the translucency of obsidian, as when I had seen her cradling the city upon her knee, sitting on the hillside of Vysehrad, but the semi-transparency of a piece of fine gauze.

She was looking at the double star, both heavenly and aquatic, which sparkled light-years away at the rim of the sky, and winked at the height of her right shoulder. Did she

remember the mysterious star which had risen centuries earlier over a village in Bohemia at the birth of a boy named John who, when he became a man – a man of faith and of his word – paid with his life for his refusal to perjure himself, and who was thrown into the Vltava at the Emperor's orders? But orders more mysterious still decreed that five stars should shine out over the water where John Nepomucen had been drowned. And more prodigious orders yet decreed that this body, buried in the cathedral of St Guy, should gradually decompose – with the exception of the tongue which, alone, remained intact, untouched by death.

The martyr's tongue remained pure and alive for all eternity, immortalised by respect for the given word, the tongue of John Nepomucen, miraculously preserved and magnified, in its undimmed endurance, proclaiming how solemn and demanding the word is.

The star had shone, at his birth and death, above the roofs of the village of Nepomuk where he had launched his fledgling cry, above the untamed river, whose flooding overturned the bridges, and where this steadfast man had breathed his final breath.

And his castaway body had been covered with stars – glittering crowfoot, words of light floating between sky and water.

* * *

Was it the echo of those words of gold and silence which the giant-woman was listening to that night, bent slightly forward above the Vltava, or was it the song of a watersprite dreaming in the depths of the water? Was it the sound of the city borne upon the current that she was listening to like that, the tears of the drowned mingling over the centuries with the streaming of the river, or the old ballads of the boatmen and raftsmen of other days? Perhaps

it was all of these, for her ear perceives the sounds of the present so acutely that she hears, at every instant, both the pulse-beat of the past and all the voices of the millennial living.

She was listening to the river, to the memory of the water and its banks, to the night over Prague, to the sounds of the living; she was listening to the star, to the memory of the star born long before the earth, and to the slight lapping of the star's reflection on the waters of this world.

* * *

Suddenly one of the swans sleeping nearby shook off its sleep, stood up, took several waddling steps and spread its wings.

When it took flight it went through the motionless body of the giant-woman. Its great opened wings and powerful body flew straight through the back of that woman of mist and vapour. Then the swan appeared for a moment as though lit up; its whiteness took on the glitter of frost and, instead of alighting on the river, it flew up high into the air and hung there for a moment, its chest thrust out, its wings arched and its neck straining upwards towards the sky. It gave one raucous cry, then sank down again towards the water, but it did not yet alight upon it; it began to walk upon the waves, striking them rapidly with its feet and flapping its powerful wings. It was as if it were dancing, in a state of extreme exultation as though in the grip of desire, and its dance had nothing of the legendary grace bestowed upon its kind.

Its dance was brutal, its wingbeats were unsteady and whirring; and its neck did not so much ripple as twist. Its dance had neither grace nor delicacy, but a rude and austere beauty. The true beauty of its race.

* * *

The swan was dancing on the surface of the water, upon the brim of the night, in the heart of the city, so near to humans yet so alien to them; it was dancing, touched to the quick by an emotion far more powerful, far more disconcerting than that of desire. It was the emotion of having gone through the body of the incorporeal giant-woman, through her age-old weeper's back. It was the emotion of feeling steeped in the mystery of pity – pity for all living flesh, whether of man or animal. It was the sudden sense of belonging to the community of the living, all creatures mingled.

The swan was dancing as a sorcerer dances when he invokes the rain, the sun or the earth's fertility. The swan was neither male nor female, and not even a bird; at that moment it was a living being, simply a living being dazzled by the obscure splendour of the flesh, by the muted song of its own blood. A living being drunk on the sense of its own pulse-beat, and on the vigour of the present. It was calling upon the light, the star, the whole city, as it pounded on the river and hammered it with its wings.

And the star trembled, in the sky and on the water, like a mouth about to utter a long-considered blessing, a declaration of love and a vow of faithfulness.

At last the swan ceased its frenzied dance, fell back upon the water and let itself be borne upon it. It went off, lazily, gliding upon the current.

The giant-woman had disappeared. The other swans and the ducks were sleeping peacefully at the water's edge. New stars were sparkling in the sky.

Tenth appearance

'Have I really ever loved anyone at all,
or was it just a lightning flash
which made me the shadow of my former self?'
<div style="text-align: right">Vladimir Holan</div>

Now the city was just black and white. The soil, in the parks and squares, had hardened into sooty sods sprinkled with fine snow, where great rooks hopped, cawing harshly. The trunks of limes and beech trees were anthracite grey and the house fronts looked blackened and scaly. But the roofs were white, the bare branches of the trees and the twigs sparkled with hoar frost and the birch trees glittered. A wan sun hung dimly in the distance, in a sky veiled by the smoke which rose in gloomy twirls from the chimneys. It was achingly cold.

People tottered by cautiously, their eyes moist with cold, their faces shrouded by the mist of their own breath. But they did not look at each other, they saw nothing; all attention was focussed upon the pavement, lacquered with layers of ice. They moved like tightrope-walkers, arms akimbo, hands poised to deaden a fall.

In a street around Karlov dustbins were steaming, full to overflowing with red ashes. A bitter smell hung on the icy air. One window on a second floor caught my attention. It alone had a bit of colour. Behind the window pane, beside a fruit-dish filled with oranges, there was an earthenware vase patterned in yellow and blue. The vase held a bunch of chrysanthemums, purple, coppery and pale ochre. Small mounds of coal formed little pyramids along the pavement, opposite the air-holes of the cellars. A dead pigeon lay at the foot on one of these half-subsiding pyramids, its coal lumps scattered around it.

That bitter day, the pile of lignite put me in mind of Kafka's short story *The Bucket Rider*, where the protagonist sets off in search of something to fill his empty stove.

'The coal is finished, the bucket is empty, the shovel is

meaningless; the stove breathes out icy blasts, the room is swollen with cold; through the window the trees are stiff with frost; the sky is just a silver breast-plate deaf to all entreaty. But I need coal, I do not yet have the right to freeze to death. Behind me is the pitiless stove, before me the no less pitiless sky; I must slip between the two and go and ask for succour from the coalman.' The speaker is so poor and stiff with cold, his need is so extreme, it makes him comical. Now we see him flying through the biting air astride his lamentably empty bucket. 'Magnificent, magnificent; seated camels do not rise more splendidly from the ground, shaking themselves under the driver's stick. We proceed down the frozen street, at a regular trot; sometimes I rise to the level of the first floor, I never go down to street level.'

The wretched fellow bedecks himself in all manner of farcical finery, capering upon his nimble bucket-steed. The numb rider is confident that with such a mount he cannot fail to attract the attention of the coalman, snug in his cosy cellar ... cannot fail to win his pity. For, elated with cold, this horseman is straight out of the Decalogue, he is a groom of God – the incarnation of the Fifth Commandment: 'Thou shalt not kill'. 'I must arrive like the beggar who, almost dead with hunger, is ready to die on the threshold in order to persuade the cook to hand over the last coffee dregs. In my case the coalman, furious but blinded by the evidence of the Commandment 'Thou shalt not kill', must throw a shovelful of coal into my bucket.'

And he calls upon the coalman with the voice of a Biblical herald, he addresses him in the name of the Law. But the good fellow is a little hard of hearing; his wife has heard all right, but she is hard of heart. What she sees is a beggar astride an empty coal bucket, gaping like a famished pike. A penniless ne'er-do-well. Let him go to the devil, this grotesque jockey, and quick about it too, him and his iron

horse, let them graze upon the chilly air of somewhere else. Let him vanish into thin air, somewhere far from their quiet, cosy corner. Then she unknots her apron and shakes it sharply to drive the importunate fellow away, as you would a bird, or a fly. The apron flaps in the snowy street, in the ringing silence of the cold air. And the little iron horse weighs so little, its horseman too is so light, that he immediately bounds off in flight. 'The draught from a woman's apron is enough to send him flying upwards.'

High in the air, he flies off towards the frozen peaks. He falls to earth in the land of icebergs and is lost there for ever, wandering amidst the tracks of the little dogs of the North. The coalman's wife, indifferent to all Commandments, has banished him to the ends of the earth, to the extremes of cold – a livid desert from which no traveller returns.

Here there was no coal shortage; the cellars were spilling it out on to the street. The frozen horseman would have been able to stuff the empty belly of his bucket by bounding from one pyramid to the next.

But there is always something missing. A moment always comes when we find ourselves mounted on an absence, on a resounding blank. And then the other, the very one from whom we are hoping to beg for help and attention, and an answer to our questions – in a word, for pity – has simply to wave their handkerchief quite casually, or their hand in irritation, for us to be catapulted straight to the outer limits of the sea of ice.

* * *

Did the giant-woman pass by that day? Was she wandering in the Karlov district, was she down there in the cellar where the coal was slowly crumbling? Was she shivering in the dry cold which stiffened the city and its passers-by, was she limping invisibly along that street? At all events she

rose and crossed through the Kafka text which had just come into my mind. She goes everywhere, lives nowhere, but haunts all places. And texts too are places – indeed they are places par excellence. They are places where anything can happen – dazzlement and shadow, and even the Word of God. They are places where solitude and absence light up, where emptiness chirrs and silence sings. A siren song in the open sea, and on open land. And the heart founders, enamoured of space, in love with immensity, forgetful of death because it is suddenly on a level with it – with its own imminent future. And the heart founders, the better to rise up to daylight once again, to the heights of the day, and to draw close to land – the land where we think we live, but which always remains promised, always on the horizon. The land towards which we have ceaselessly to return, using all ways, be they of mud, stone, water or sky. And the ways of ink have some of the characteristics of all of them: they are shortcuts through tortuous labyrinths which sometimes deposit us unceremoniously in the clearest of clearings. One moment life is there, and we are in the world. We stand right there in its midst, at the core of the world, whose meaning and full beauty we feel we are at last approaching. For one moment life is there, light-filled, and the world is for the taking. It does not last, but it leaves traces – runes of *amour fou* graven deep in the flesh, in memory, and in desirous thought. Runes whose songs sing in our blood for a long time.

The giant-woman crosses these texts, which shipwreck the heart in order to render it more universal, if only for the time of a heart-beat. Her step resonates in their words, her tears shine out between their lines.

So that day too, she called quietly from within a text which the sight of a heap of coal had just recalled to me. And for a moment it seemed to me that if I bent down towards the air-vent half covered by the mass of lignite, I

would see her eyes, raised from the depths of the coal-filled cellar. Her great eyes, unbearably tender and weeping uncontrollably: almost transparent, beseeching, light-devouring, consumed with pity. Hers is a look you cannot meet without losing your reason – it seizes you by the throat and does not let you go; encircling you so quietly that you want to cry for all time, to cry with her tears.

I did not look; I continued on my way. And yet I did see her, and see her still.

* * *

She said nothing that day, she never does. But she shattered that text like a window pane, and all the splinters of glass, all the fragments of frost, fell upon me. And, once again, the splendour of desire, the wonderment of boundless love – and the pain of loving – began to murmur their obsessive antiphon.

* * *

Astride a coal bucket – that is how those who are cold to the very marrow of their bones, to their very veins, go about the streets. Astride a bread bin: that is how those who are hungry go about the streets, with hunger squatting in every pore, running rankly along each nerve. No one sees them, they are so light; they are transparent, they fly above our heads. And if by chance we do see them, we quickly look away. A mere blink is enough to drive them away, they fly off like old papers carried by the wind: the ill wind of poverty; of misfortune.

Astride a name: that too can happen. Suddenly we find ourselves perched, gaunt and pitiful, on the name of the one who has left us, who has deserted our love. The abandonment, the betrayal are so cruel, that they wrench us from ourselves, lift us from the ground like a bit of chaff. So much do we miss the body of the other – which has

slipped away from our own, to offer itself elsewhere – that we become deprived of the weight of our own flesh. For the body of the only other had become our ballast in this world; over time, indeed, it had become our real self – a self of sensual enjoyment and of tenderness.

<p align="center">* * *</p>

We are made up of the flesh of others: of the two bodies of our parents; of those who grew up beside us, our brothers and sisters; and of those who in their turn are begotten of our flesh, those child-bodies which need long watching over, so that they may ripen and grow, and step out squarely beyond the boundaries we have drawn for them. Then there is the one who suddenly appears, from elsewhere, who breaks off from the crowd one day and comes towards us, so close that its breath mingles with our own, that its face enters our own. This is the lover, who becomes our body's twin: our second body. Who, although alien, because alien, becomes consubstantial with us, through the ways of desire which run oblique to those of consanguinity.

Because we have looked upon it, encircled it, caressed it, slept up against it, in its warmth and smell, because we have desired it with a desire ever-growing even at the height of its sating, we know that other as no other knows it – as no other can or should know it.

The lover's body is sacred, it is pure, even in the heat and groanings of fulfilled desire. It is our secret, pride and happiness – a fertile happiness which feeds all our other moments of happiness, all our other outstretchings towards the world. It is the stone put up along the way, at each crossroads whose text is constantly renewed and which we never weary of rereading, with our lips and fingers as much as with our eyes.

<p align="center">* * *</p>

We thought this second body was our own, inseparable from us, tirelessly colluding. We deluded ourselves. Now suddenly off it goes, denying and forgetting us. The pain enters everywhere, and reason, cling to it though we may, shatters and crumbles. Reason will no longer listen; fear takes over. We collide with the absence of the other, not knowing where to go, where to hide, or flee. We are humiliated, we catch ourselves desperately waiting for his figure on the street, in the crowd; jumping at the least sound, as though he were returning; all footsteps are his footsteps. But he, she, is walking elsewhere, so far from us, and quite indifferent. We accuse, curse and insult him, but forgiveness is already taking shape within us. We want to die, but we live on, straining with the mad desire to see him again. Once more, just once, only once. We hate him, but we call upon him with immense patience, with the pain and love of the prophets recalling their frivolous flock to faithfulness. We deride, we speak ill of the unfaithful one – we blaspheme, but a beggar squatting within us holds out a hand imploringly.

And we fly off, astride a name; we drift towards the icy summits of silence where our tears and calls freeze up. We shiver – we are so cold, so naked. We beseech the other to come and clothe our nakedness with his body. We are so naked that we are flayed, half-skinned. We are naked to our very heart. And we feel infinitely small, and ugly, all shrunk with grief and cold, undesirable to ourselves, to everyone, because we are no longer desired by the other, who will never return.

* * *

Then we retreat into our emptiness, without words, or breath, to call him. We are beaten. *Amour fou* has ceased to make us weightless, and we fall back, heavy with absence, grief and shame. 'White summits on all sides, and my

bucket the only dark touch. I was up there just then, now I am down here, twisting my neck to look towards the mountains. Expanses of ice covered with white hoar frost, scored with streaks left by the tracks of vanished skaters. I walk on the deep unyielding snow, in the tracks of little Arctic dogs. My ride has lost all meaning; I come down, carrying my bucket on my shoulder.'

The steps of the giant-woman made the text crunch, and the Fifth Commandment rang out in the frozen air. But the city was deaf, the earth a black firn, the sky an iron breastplate. Forsaken lovers were shrinking along the walls, heads lowered, lips sealed, blue with cold. But no one noticed them – you are so insubstantial when you plummet to reach the depths of unhappiness. The giant-woman was weeping in the cellars, crouching by the coal heaps. There in the filth and cold she was silently weeping for the pain of lovers who are no longer loved.

Eleventh appearance

'Ah! Whence comes all that from which we flow?
Whose were those nights which pile up on my own?
We have kept watch so long, we know no other stance.
I have discovered my fall. How?
In tears!'

<div align="right">Jiri Orten</div>

The tram crossed the Palacky bridge; the trees on the three little islands slightly downstream were just coming into leaf. The bright facade of the distant castle over-looking the roofs and gardens of Mala Strana disappeared suddenly when the tram set off up grey Lidicka street. Then it turned into the endless Plzenska avenue. When it reached Bertramka station, a fine sleet began to fall, though the cold, pinkish daylight was unaltered. Behind the rusty grilles of the old cemetery of Mala Strana the silhouettes of the stone angels and orants on the tombs stood out like shepherds watching over the calm and silence. A gardener was wheeling a barrow of faggots along the empty path between the tombs. The sleet was slanting down, a flight of silvery down caught in the light, emphasising the verticality of crosses and statues.

As the tram continued along its way, the architecture of the Kosire district became less and less uniform; nineteenth-century houses, their leprous roughcast black with soot, cornices half eaten away, windows grimy or broken, stood alongside more recent buildings, heavy rectangles of reinforced concrete: their facades, too, were dirtied with brownish streaks and cracks, and they alternated with old factory buildings of a grimy ochre colour. Here and there great gaps punctuated the motley line-up. This is how towns devour neighbouring villages, in mingled haste and carelessness, casual greed and rambling indifference.

The endless Plzenska avenue then crosses a strange no man's land, its buildings standing well back from the road. It is as if the town had ended. There is a general sense of abandon; fallow land lies along the embankments of black leaf mould. But the sense of abandon culminates at the

station for the Motol crematorium: a rocky spur, topped by a cross, mounts guard over this city of ashes. Again one feels the haste which reigns in the heart of city-dwellers; they burn their dead, inflicting this final violence upon them, expediting their disappearance, without leaving them to become one with the earth. They tear down houses, banish remnants, bury landscapes, incinerate bodies whose life has only just ebbed away, running headlong, increasingly breathless, over an ever diminishing space.

When the houses start up again, a little further on, perched at the sides of little sloping gardens, they look like survivors from some village shipwreck.

* * *

The tram went on its grinding way. The pink was draining from the sky, the sleet had stopped but the asphalt was gleaming; so was the bark of the trees, and the dark earth and the boulders at the edge of the road. Water was dripping from the branches, rivulets of bright raindrops ran down the windows of the tram. The new grass had not yet sprouted; tufts of withered weeds, rust-coloured stems, bare brambles, bushes with brown or purplish branches were scattered over the slopes. But you could see the buds were swelling, you could see the tiny bundles of pale green or yellow catkins. Everything was about to break out. Faltering on the brim of winter, the landscape was dashed with the bright yellow of early forsythia. The tram ran like a tightrope walker on the brink of two seasons.

At the end of the line, at Repy, there was a huge council estate; work was still going on around its edges. A partly paved road led towards the buildings, zigzagging between empty lots and building sites, dipping under the low arch of a road bridge.

* * *

The sky had turned lilac. Under the vault of the bridge, graffiti proclaimed the vows of adolescent love. In the undergrowth of the empty lots, cuckoos and warblers sang shrill and jubilant. At the balconies, washing billowed slowly. The building site was muddy; the corrugated iron paling surrounding it was askew and disjointed; rain water had collected in deep potholes. There were pockets of rubbish and piles of rusting tools. Sparrows hopped around; the earth disgorged rosy worms gobbled up by little birds between melodious warblings. The sky was darkening fitfully, now it was a voilet purple. The soaked earth gave out a smell of must, roots and rust.

* * *

Was it also the smell of her immaterial body that the city's earth was exhaling, her garments which were veiling the horizon, and she who, in her wake, had just raised that slight wind which chilled the damp air yet further?

It could only be she, even if I did not see her. For a moment her presence could be felt in the air. She had just passed by, quick and weightless, borne on the evening wind.

And instantly the utterly ordinary landscape which surrounded me rose above its banality. Or rather, the dullness of this bleak suburban landscape was heightened to such a degree that it claimed total attention for each portion of its surface and texture. The least thing began to demand a rapt attention. Now nothing was beautiful or ugly, there was no longer any question of evaluation or judgment. Nor did it matter that the place was more or less ordinary, that the entrance to the block of concrete buildings was dirty and desolate; it would have been the same in the Strahov park, or the Wrtba terraced gardens or the Lobkovic palace.

The place was there, in all its power and nakedness – its wretchedness or splendour no longer mattered.

Where the giant-woman passes, the earth is raised above

our carelessness, things are plucked from the indifference to which we relegate them, matter reveals itself, grainy, knotty, massive, porous, kneaded from time. Everything takes on a smell, a taste, a presence.

Where the giant-woman passes, the scales fall from our eyes. Now the visible world reigns supreme! Suddenly we are astonished to find that we are alive, secured to the earth, flesh and blood, moored in space and time with all the force of our living and yearning bodies. And in a single movement we enter the density of the visible world as the figurehead of a ship cleaves the mass of the sea, before rising and sinking, streaming – spattered, slapped, eroded by the violent water. A figurehead washed, polished, burnished by the satin-soft icy water.

The limping giant-woman has but to pass us by – however briefly – and we stand erect, our feet solidly planted on the ground, our faces in the wind, our eyes open to the visible, the palpable. We stand erect at the wandering heart of the world, on the threshold of its secret glory.

* * *

The street-lights came on. One of them cast its halo of light over a muddy puddle where a shoe was lying. A man's shoe of mouldering leather where a scrap of lace still hung.

And the realm of the visible was concentrated around that poor object, that old leather shoe, split and scuffed.

It gaped, still vaguely retaining the form of the foot which must have long worn it, and worn it out. An old discarded shoe, of use to no one, but stubbornly retaining the marks of its past usefulness: to sheathe and hold the foot of a walking man, to strengthen and support his foot upon the earth. To walk, to bear the weight of a body, to be part of the movement of that body.

A man's shoe; a shoe still bearing witness to a man's life, to the weight of a man upon earth, and to his progress through this world.

An abandoned shoe, already beginning to rot in the mud. Was there still anyone in this city or its suburbs to recognise that old shoe as having been his, or as belonging to someone close to him? For the objects belonging to the body, everything which clothes it, sometimes end up becoming almost part of that body, an expression of it.

* * *

We dress the dead. They should always take their leave naked, though; the wood of the coffin is enough to cover them. There is not the least immodesty about the nakedness of a corpse. Be it of child or old man, what is designated by the ugly name of corpse is stripped of sexuality. The word 'spoil' is more accurate, for it is indeed an absolute despoilment. Now the body is despoiled of its breath, of all that made it move, of all that assured it a dwelling place upon this earth. The kisses and caresses we would still like to lavish upon the frozen, rigid body are no longer moved by the sweet stirrings of desire. They are the gestures at once of supplicants, orants, donors and beggars; of every infinitely loving mother and of every frightened little child: animal gestures, like a female licking her young. Sacred gestures, like a celebrant intent upon the sacred text and the objects of the litany. They are gestures of the deepest chastity.

The body of the dead becomes a face whose vulnerability is consummate, and where the mystery of the human soul is shown forth blindingly. It is as though the soul, on leaving the body with which it had been one since birth, had welled up from the depths of the flesh, becoming almost visible, haloing the skin. As though the soul, astonished at being suddenly unburdened of this living flesh which had been its own, now enveloped the body with its own astonishment, remaining for a moment, hesitant, upon the body's surface. The least grain of the skin becomes a temporary resting-place for the departing soul.

Just as the gaze is a naked force, elusive and intangible, which shines forth from the eyes – a disembodied presence – which claims, touches and troubles us, so the souls of the dead filter through their spent flesh.

* * *

As they lie upon their deathbed, the feet of the dead rise up naked, the sole for ever lifted, separated from the ground.

Death proclaims itself – with terrible intensity, with disconcerting and sovereign gravity – upon the bare and livid soles of the feet of the dead. Through their unshod feet, death proclaims that from now on all sojourn on earth is impossible for the man or woman who lies there; that their time is done, that they may take no further step on earth below; that, now, all that remains is to accomplish the invisible step into the next world.

The very bare and solitary next world.

* * *

But the feet of the dead, which we still want to take in our hands and warm, on which we let our tears fall, reject us in silence with their irremediable and implacable nakedness.

The feet of the dead, rising upwards in stark contrast to the horizontal of the hands crossed on the silent breast, of the mineral face. The soles of their feet, etched with lines, with hardened furrows, never to touch the earth again.

The feet of the dead, which walk through our nights and pace through our dreams.

The feet of the dead are laid, frozen and bare, against our hearts, where they etch the lines and furrows of the desert which extends beneath them.

The feet of the dead – whose soles have become their faces.

* * *

And their shoes remain, piled up in cupboards, witnesses to their dispossession; witnesses to a break in life, for ever. They are thrown away, given away, so that we no longer have to endure the sight of them, unbearably immobile. Or we may wear them in our turn, to continue with the path of life in the steps of those who are gone.

We always walk in the footsteps of the dead; we always limp a little after they have ceased to walk.

* * *

The halo of light quivered in the puddle, the wind was quietly lifting the shred of shoelace.

The giant-woman herself never leaves any footsteps. Have I ever seen her feet? I do not think so. During her brief appearances I have noticed only her general tall outline, her back and her broad shoulders.

But what shoes could she wear, who walks only in the footsteps of others? She could not but go barefoot, like the slaves of days gone by, like the poor of all times.

That is why places are transfigured as she passes, why they become points of tangency between earth and heaven, the living and the dead; that is why the visible world dazzles at her passing, streams with invisibility.

Every place is holy where the limping giant-woman passes, her body heavy with the memory of men, her steps lighter than the breeze.

Every place is holy – but not sacred – where the weeping woman passes, for a holy place sings softly of an alliance between God and men, while a place that is declared sacred drives man from the mystery of mercy, banishes him to the marges of violence.

The least place is holy in this world the moment you stand there as a poor man – an undemanding guest, asking for nothing except remembrance, and others' mindfulness.

Last appearance

'Come, come and look
It's somewhere, but where
They've hidden it,
It's something, but what
Search and find it.'
 Ivan Wernisch

Never, since her first appearance, had she remained so long unseen; almost a year. It was as though she had gone away, left the city. And then one day, suddenly, one bright October morning, she reappeared.

Only to disappear again for good. It was a silent farewell, and very brief. It took place on an avenue in Liben. She emerged from the trunk of a tree on the edge of the pavement, just beyond the tram stop where I was waiting; she hurried across the street without looking around her and marched straight to the opposite pavement in front of a large building. She went through the grey wall of this ordinary building as though it were mist, and disappeared.

For the first time she left behind her no emotion, no image; no resonance rose in her wake. Her passing caused no jolt of memory, sowed no dream, did not suspend the moment. Nothing happened; nothing except the cold acknowledgement that I had seen her again, and the even colder knowledge that it was for the last time.

The indifference which marked this appearance was too deep, too acute, not to mean something – a farewell, as it happened. She who, at each of her appearances, had always tacked through the realm of the visible so mysteriously and dreamily, was now suddenly charging across the street like an ordinary citizen in a hurry to catch a bus. That was how she took her leave, with a quick, brutal, casual farewell.

What urgency was driving her so, summoning her elsewhere – and where? Had she been inside the tree all along, had she hibernated for all those long months under the bark, or had she been watching there, leaning against that trunk, invisible? Or indeed had she gone through the city,

mingled with the crowds, waited in some cellar, in a square, under a church doorway, in a courtyard?

And why this sudden haste and this brusque farewell? Was she going to stay in the building into whose grey stones she had just melted, or had she already gone right through it to continue her progress on the other side – progress towards what?

* * *

Perhaps one day she may reappear, later, here or elsewhere. But it is unlikely. And even if she did return, it would no longer be quite the same. The meetings with her had been too emotional, too laden with dreams and memories and confused desires for a new cycle of encounters to begin again after such a break, as though nothing had happened, as though the rhythm of the first appearances, however discontinuous and unpredictable, had not been broken.

All love, whether of parent, brother, sister or lover, for ever bears the mark of its inevitable end, for ever bears the wound of that leave-taking, even if the other, the beloved, the prodigal, eventually returns to us and is ours once more. And there was love in her, all around her: the deepest, most patient and generous love – the tenderness, the pity which is mercy.

It is possible that she may return to the visible world, but further sight of her might unsettle that world too deeply, might open too wide a breach in it – drawing attention to horizons that are unbearable for the eyes of the living; as if a dead man were to come back and sit down at our table, laying his untouchable hands upon the wood of that table and casting his eyes, dimmed by the brightness of another world, upon our astonished faces.

There were so many faces and voices in the folds of her dress. Henceforth the vast tribe of the dead who sleep among her rags will also number the face and voice of my

father. And of others too who have joined him since, in the mystery of disappearance towards whose threshold our attention is ceaselessly drawn – but which we shun in fear.

<p align="center">* * *</p>

Henceforth they will include the face, the smile and the voice of that man who precedes me in all things – in life and in death, before and beyond. And between the two there is his broken body, long bedridden, long suffering; delivered to the hands of others endlessly performing acts of care, and safeguarding. But which one evening were suddenly left empty, useless, gaping when his breath broke off.

Henceforth. And that is how we live: from henceforth to henceforth.

Epilogue

'The bird sings on,
the deer runs on,
and thus they may lose their way;
should a fish venture into the net,
he can find no way out.

And human reason too
sometimes hobbles itself
and cannot encompass everything:
the person who can make
every dream plain,
is not yet born'.

Petr Benicky z Turce

She has left the city. The seasons go by, rain, mist, sun and snow punctuate the days, but she does not return.

Her tall silhouette no longer looms: not in the little streets of the old city nor in the outskirts, nor along the banks where swans and ducks cluster, nor on the hillside of Vysehrad or Petrin.

Her long low murmuring of tears is heard no longer on the wind nor in the scent of the lilacs, nor on the bark of the silver birches in the parks nor on the shivering leaves of the limes; it no longer comes to rest on the hands of the statues outstretched towards the distant sky in gestures as imperious as they are agonised.

Her great non-fleshly body no longer sails through the walls of houses or rooms, no longer summons up faces from the sky, or the blackened roughcast of the house fronts, or the flowered wallpaper.

The passers-by come and go, loitering or hastening along the streets, boulevards or alleyways, but she is no longer among them. She has left these places.

* * *

But what exactly are places? Are they our dreams, or is it they which dream us? The physicality of places is interwoven with so much that is imaginary. The stone, iron or concrete are never as dense and solid as they seem; by its endless movement over them, time finally uncovers a certain fragile porosity as on a human skin. Time marries matter, coils up within it, engendering marks, faults and age-rings. Time breathes, beats in the stone, on the surface of the roughcast, very faintly, barely audibly, like the heart of a child in its mother's womb: the heart of a child for ever to be born.

The giant-woman is born out of the stones of Prague, from the marriage of time with the whole city. In the legendary days when the princess Libuse foresaw the future glory of the city, the giant-woman was already discernible in the shadows of this glory to come, like a twin sister: a sister without grace or lustre, already disinherited and rejected, the transposed double of the other, as the court jester is of the queen. Inseparable sisters, whether this glory is at its height, or totally eclipsed.

She was born of the stones of Prague, of all its stones – those of the castle of Hradcany as well as those of Vysehrad, of their ramparts and their powers, and of those of the bridges, the basilicas and the churches, the palaces and the houses of the poor, the paving of the streets, the steps of the staircases, the alleys of the ghetto. She was born of the stone and of the wood of which the city was built, through which it took form. She burned in the stone and wood each time fire broke out, she flowed with the waters of the river with each flood which tore at the banks and overturned the bridges.

She soughed in the wind of the storms, sparkled in the rain, in leaves and on rooftops, she cracked in the waters of the frozen river and shifted in the autumn fogs; she burned on the pyres and knelt down millions and millions of times in the cemeteries with their bristling crosses and steles, furrowed with paupers' graves. She sang in the gardens, in the trees in flower, in orchards and in squares. She died a thousand deaths during wars and uprisings, great epidemics and pogroms. She often took the road to exile with the banished, the road to darkness with the deportees; sometimes, too, she took the strait and hard route heavenwards with the saints and the just.

She was born of wood and stone, metal and water, and of the countless bodies of the city's dwellers. She is born each day through the strata of the centuries and the flesh of

History. She is born, she never ceases to be born, picking herself up, more lame and drifting than ever, after each fall, each death, each violent end.

She is the city's memory – the dark side of memory, that of the poor and unimportant, of all those whose names and suffering History does not record. She is memory stripped of all glory, unwritten memory, unillustrated memory, unpainted with the gilt of myth and legend. She is memory in tatters, with an empty stomach and hollow eyes – but with a radiant expression of humility and tenderness. She is suppliant suffering and weeping memory; but steadfast, adamant, and loyal to her people. She is memory which never falters, but walks on, not yielding, even for one moment, to repudiation, denial or lies; gleaning all the refuse thrown out by her grand, haughty and selective sister. She garners the tiny, lowly destinies of those who have not.

* * *

So she cannot have left the city, deserted it for ever. That is impossible and cannot ever be, since she is one with the city, since she is its ghostly heart.

* * *

It is not the city that she has left but the realm of the visible. She has slipped back inside the stone, beneath the bark of the trees, into their roots, under the asphalt of the pavements. And the steps of the passers-by echo above her, around her. She has dissolved into the city, as Wu-Tao-Tzu melted, it is said, into the silken mist of a landscape he had just painted. And the passer-by walks through her without even noticing.

She has withdrawn from the realm of the visible as a rainbow fades from the sky, leaving it quite bare. But our eyes continue to be drawn by the distant haze of colour,

although it has vanished; our eyes remain captivated by, nostalgic for, that glimpse of beauty.

She has gone back into her element: the halo of invisibility which surrounds all things, the immensity which lies on the reverse side of our finitude, and the crystalline song of silence, a holy response which constantly accompanies the sound of the world, the clamour of the peoples.

She has withdrawn from our sight, which sees so little, which is ignorant of so many colours, forms and movements; and she has withdrawn from our hearing which is so poor, which is ignorant of so many sounds, of so much music and silence. Who senses the aura surrounding plants, trees and bodies, who seizes the infinitesimal melody which purrs around us? Even those who do sense them can do so very rarely, and very briefly.

She is the aura issuing from the stones of the city, from all the substances and living flesh which ever inhabited it, rising from the ground and rock upon which the city has gradually grown up and expanded. An aura so delicate that the glow of other auras sometimes echoes in it – over the centuries – for every city, every place has its own aura, woven at the extreme limit of the visible. There is no city, no place, which does not have its disembodied heart, unique, unnameable and immemorial.

* * *

She has withdrawn from the realm of the visible – or perhaps she has simply changed shape, perhaps she continues to appear under a new form? That of the sparrows in the parks, pecking at the crusts of bread scattered by some old woman anxious to share because she lives alone, cast off by the living and awaited by the dead; or that of a stray, ownerless mongrel, or one of the crying gulls which haunt the river? Perhaps she is now nothing but an almost vanished face, hesitant behind a hospice window, or perhaps

she has scattered herself in the sand of a park where children come to play? Perhaps she is the brightness of a cluster of candles burning softly in a chapel, at the foot of a saint, of a Virgin and Child or a Virgin of Sorrows; perhaps she is the glow in the sky at nightfall when the Sabbath Bride arrives, her fingers already sparkling, her nails pure and transparent in the light of the candles and the joy of the songs raised in her honour? Perhaps she is in the down of the swans which the old pick up with such care on the river banks, perhaps she dances in the swaying shadow of a drunkard groping his way homeward unsteadily, bawling an endless refrain. Perhaps.

Then she must be revealing her presence to other passers-by, suddenly stirring deeply buried memories, desires and visions long conceived, but whose hour had never come.

She lets her murmuring of tears be heard by other passers-by, manifesting her vast memory to them. She sows other faces, other voices in the thoughts of these other, new passers-by – stopped in their tracks by a sudden delicate concern.

To me she reveals herself only by her absence.

* * *

Quite simply, it is the book she has left. Not the city, but the book.

Yet she entered the book so rarely, she spent so little time there. The occasional visit, or image – short and incomplete. The fault lies entirely with the scribe, not with her.

The fault lies entirely with the scribe who was unable to write 'at her dictation' during her appearances at street corners, or during her confused weeping. It is the fault of the scribe who began to write when the visions had already ceased, and the smell of ink was already fading, and when

the words were shrinking to a mere handful of signs, instead of expanding to take in the shifting and polyphonic world which each of them conceals. The giant-woman made words shatter like flint, like a thunderbolt, giving them back all their primeval power, the ringing, cutting edge which was theirs when they burst forth upon the spearhead of lightning as it struck the ground. She made words split like the skin of fruit with the moist sweet-smelling flesh beneath, the sharp juice running, kernels or almonds gleaming. She made rivers well up in words, forests take leaf and plains expand, roads zigzag and clouds run. Birds flew off through the vastness of the space contained in her words, colours tumbled in them like haystacks scattered by the wind. Words began to move, to resonate, like bells with their clappers shaken. Their sounds commingled.

The word tree became covered with grey or brown bark, ivory or silvery, and sank deep into the earth, under grass and rubble, and gave out a smell of sap, roots, moss and damp leaves; creatures nested there, eyes sparkled in the branches. The eyes of mice, of martens, of wild cats and dormice, of fireflies and ocellated butterflies, eyes of the sun or rain iridescent with the stirring leaves. The eyes of children scanning the horizon from high in the branches, or just dreaming.

The word tree embraced the world, delved into the earth, burrowed into the humus, and at the same time explored the sky, tearing down strips of light; it stood amidst the glory of the earth, marked time for the centuries through the seasons and gathered the memory of the place surrounding it into its ever more gnarled and strong-limbed body.

Where the giant-woman passed, if there was a tree nearby, the word tree was suddenly rebaptised in all the splendour and power of its first naming, however insignificant and ordinary that town tree was. Where the giant-woman passed,

the least thing was clothed again in all the breadth of its name, the dreariest, most sickly bush was linked again to the memory of its race – its high and legendary race of trees.

* * *

Where the limping woman passed the city no longer rejected nature; iron, stone and concrete appeared in their full physicality, quite as much as trees and tender-stemmed flowers, or the vulnerable flesh of men. Each inhabited its own name in all its plenitude and roundness.

Where the weeping woman passed the whole city, in its least corners and details, rediscovered the memory of itself as place, of its plinth of earth filled with remnants, bones, stocks and substances.

She, the disembodied one, the evanescent Weeper, made each object burgeon in the wholeness of its substance. Words and names declared themselves living things.

As she passed, everything throbbed and became palpable – even names and voices, expressions, the gestures of the absent, and those of the dead. The word face rose up like a frail moon, so near you could touch it with your finger-tips, sense the grain of its skin, the blue of the veins beneath. The word face was tendered like the palm of a beggar at the mercy of each and every one. The word face became infinitely small and infinitely vulnerable like a may-fly; yet, in a single movement, it expanded to take on the dimensions of a boundless horizon where anything can happen. And the shadows of the night and the day's brightness crossed this vast horizon by turns.

A horizon where everything may be revealed – the waters of the Flood, the flames of Sodom and Gomorrah, the sands of the desert of exile or the water of a lustral spring, the flame of a clay lamp, the sand of the desert where a voice comes forward.

A horizon where everything may be compelled – even the angel who cannot be named because his name is marvellous.

Lastly, a horizon where everything may be dispelled, may turn turtle into nothingness – even man, named and cast out for having ridiculed, betrayed, slaughtered his race. A race unique upon the earth.

The word child rang out with a sound so true that all the lies, violence and baseness which so abundantly befoul the reality designated by this word, stood instantly arraigned; the harshest light fell upon the myriad crimes committed upon children.

The word child rang out, clear and high. It was demanding justice. It was reclaiming its due – deference, delicacy, and a careful love of the adult to come, of the adult slowly and fragilely unfolding. It would brook no slight, no slur.

The word lover rang out with a very pure sound, at once quick and grave. It demanded gifts, sharing and reciprocity. In it the body was magnified, and the flesh exulted.

And the word wind set all winds stirring, from the light breeze to the most violent squall. The word wind leapt from the sea, breached the sky, struck the earth. And in its course it carried off not just leaves, branches, clouds and birds, but also colours, scents and voices. It quickened the heart, sharpened all the senses. In its haste it also carried off the heartbeats, glances, smiles and tears of the dead as of the living; it dislodged them from forgetfulness, galvanised them, churned them up, hurled them forth to the prow of the present. It summoned memory to be fully present, fully attentive. It dashed strength and brightness over all it passed through. It lashed the moment, matter and the world of the visible; they drew themselves up, sparkling, and reality rose sharply, bathed in vision, enamelled with dreams.

The word wind marshalled all words, blew within them, gave them life. It lowed from within the ink.

* * *

But where was the word God? Was it uttered? The steps of the giant-woman caused the silence contained within this word to echo, it made the absence running through its letters toll, it made it glow.

The word God has the resonance of an empty tomb with a mourner bending over it; the void sends us back the echo of our calls. This echo comes from far away, reverberating from every point on the windrose, weaving over the whole earth, taking on new tones as it crosses each face, each living body.

This echo does not come from ourselves, even if it is we who proffer the initial call. It comes from elsewhere — and summons us towards that other place. Because before our call, before the earth itself, before the great night of the world, the voice of God has already rung out. Our call, which we believe comes first, in truth always comes second. That is why the name of God is the most empty of all words and can never embrace, master or retain the meaning it dares thus designate. This meaning escapes the word, it overflows it on all sides. It is as though we were to put up a rampart of bronze against the sea; at high tide the sea would hammer against it and we would say to each other, pointing to the sounding rampart: 'That hollow sound is the sea.' And then we would know nothing of the water's immensity, or splendour, of its chasms, its swell and delicate foam, its colour, reflections, glitter and shadow. We would know nothing of the taste of salt which sharpens thirst, of the sea wind as it breathes upon our skin and captivates our eye, our hearts, our thoughts. We would know nothing of the sea's siren song, the lure of the horizon and the insatiable desire to sail towards it.

The word God is a bronze slab set on a bottomless pit, a

door between ourselves and eternity, and infinity. Between us and the highest joy of loving.

※ ※ ※

The giant-woman walks between these two spaces, these two temporalities, and that is why she limps. She limps all the more in that she never manages to balance the crushing weight of crime and pain, of evil and ugliness, against the boundless pity which comes from God.

※ ※ ※

She left the book, leaving it unfinished, fallow. She went off to roam elsewhere, in another fashion.

A disembodied giant born of the refraction of the pity of God in the tears of men, she left the book, which fails fully to express this pity.

Or rather, it is not a book, but a sifting of calls and echoes. A limping text, a stuttering. A weeping of ink. Anticipation.

※ ※ ※

Everything remains to be said, to be done. To be rewritten. On perhaps, rather, to be read – for it is the others, the living and the dead, who already make up the book, and every book.

Everything remains to be read through the tears in her eyes, through their prism of pity. A pity which is also, above all, pride on behalf of others, and a demand for dignity.

Everything remains to be read through the pure transparence of her beggar's tears; even death, which approaches from one moment to the next.

Or is it death which is already looking at us with her eyes, iridescent with tears?

When our death comes, there is no temporizing – it will

be time to accept the final invitation from the angel we have fled and rejected all our days. It will be time to agree to dispossession, to love and humility, and to say: 'I am here!'

'I am here.' The words of the threshold and the step beyond. The words of summons.

The giant-woman has said just that, even in her absences.

She is here. And the fragmentary book breaks off. She is on her way. Already she is elsewhere. Where?

It matters little; in the mysterious geographies of anticipation and desiring thought, beyond self-abnegation, here and elsewhere are but one place.

She has left the book; henceforth there is no page for her. The ink fades into transparency. But she is always here, the Weeping Woman of the streets of Prague and of all the ways of the world.

She is here.